GOING PUBLIC

PUBLIC ARCHITECTURE, URBANISM AND INTERVENTIONS

gestalten

CONTENTS

pp. 4–7
PREFACE

pp. 8–61
CHAPTER 01
GIMME SHELTER
PUBLIC ARCHITECTURE AS PLACE-MAKER

pp. 62–87
CHAPTER 02
CONSTANT GARDENER
GREEN SPACE IN THE CITY

pp. 88–129
CHAPTER 03
WALK W8TH ME
MODES OF SPATIAL MOBILIZATION

pp. 130–173
CHAPTER 04
BENCHMARKS
ACCOMMODATING THE CITYSCAPE

pp. 174–209
CHAPTER 05
BETWEEN A ROCK AND A HARD PLACE
ARCHITECTURES OF INTERMEDIATE STATUS

pp. 210–265
CHAPTER 06
WHY DON'T WE DO IT IN THE ROAD?
NEW FORMS OF ENGAGEMENT IN THE CITY

pp. 266–271
INDEX

p. 272
IMPRINT

GOING PUBLIC!

ADVOCATING SPATIAL PLURALITY IN THE PUBLIC REALM

BY LUKAS FEIREISS

As cities across the globe grow in scale, with associated changes to our way of life in today's modern world, the articulation of novel concepts and strategies in urban thinking and planning, both institutionalized and through informal interactions, has intensified. These global changes currently dominate the critical and creative spatial discourse all around the world. The discussion in the last decade of the twentieth century primarily centered around the observation that democratic public space was being destroyed by the seemingly inexorable privatization of previously publicly owned spaces. We are now more than a decade into the twenty-first century and are witnessing a local and global resurgence of so-called public and collective space, from Tahrir Square to Wall Street, which is seen in part as a platform for social and political mobilization. Against the backdrop of these highly topical phenomena, the ongoing discussion has been expanded beyond traditional notions of public space to advocate the generation and facilitation of new spaces that act as flexible frameworks for the multiple opportunities and possibilities for social, political, and cultural change.

This book intentionally avoids the terminological trench concerning the proper definition of the term public space (which can be traced back to the very origins of philosophy). The book instead looks into contemporary creative building practices in the public domain, activities true to the emphatic **GOING PUBLIC!** in its title. Interventions can be found in both the built as well as the natural environment, ranging from small to large-scale, ephemeral to permanent, playful to formal, and from individual to collective actions. Despite the great diversity of approaches collected in this book, the projects have a common thread in their affirmative endeavor to transform abstract spaces to concrete places. This deliberate transformation of the former to the latter can be described in short as the process by which a particular part of our spatial environment is activated, adding value of experience and meaning. These transformative actions allow for individual and intimate, as well as a collective and shared appropriation of our environment on an aesthetic, functional, social, and political level.

Public space in this book therefore is addressed as an integral element of sociocultural interaction within urban as well as rural environments, shared by everyone. Rather than describing public space from a mono-functional perspective as a geographically localized and static area, the projects understand public space as ever-changing, altered places within the spatial fabric of life, where this constant change plays a vital role in the natural formation and transformation of our immediate environment. As a book which considers hybrid and multifunctional space beyond traditional urbanist, architectural, and political conventions, **GOING PUBLIC!** examines each public place as a discursive space of encounter, an alternative site of artistic creation and cultural production, and as a highly social and political arena.

Offering an inspiring overview of exemplary projects that illustrate the potential for sustaining, reordering, expanding, designing, and inventing new places in the public sphere, this book organizes these projects into six chapters that partially overlap thematically. The first chapter, **GIMME SHELTER ~ Public Architecture as Place-Maker,** looks at temporary pavilions and installations, as well as permanent architecture from town to country that offers roof and shelter to a variety of programs and activities. The examples range from student-led community-built projects to urban stages and arenas that reactivate neglected spaces within the city all the way to the redevelopment of entire city plazas. The second chapter, **CONSTANT GARDENER ~ Green Spaces in the City,** is dedicated to projects that blur the boundaries between city and nature, landscaping and city planning. Topographical transformations and urban parks of different sizes are among the green oases found in this chapter, and they invite the passerby to linger and reflect. The

projects in the next chapter, **WALK WITH ME ~ Modes of Spatial Mobilization**, describe scenic and innovative modes of individual and collective orientation, traffic and transfer, which allow for spectacular and surprising viewpoints of the city and its variegated landscapes. The reader is thereby taken on a journey from colorful shoreline walkways to medieval city centers, or crowded boulevards and roller coaster–like bridges up to mountain plateaus. **BENCHMARKS ~ Accommodating the Cityscape**, the next chapter, looks at examples of multi-use, open-air objects and installations intended to accommodate and support various activities as publicly accessible urban furniture. One will see pop-up street furniture emerging from the pavement, public skateboard bowls, protruding fences that act as seats and benches, and entire city quarters coated in a chromatic blaze. The second to last chapter, **BETWEEN A ROCK AND A HARD PLACE ~ Architectures of Intermediate Status**, summons projects from around the world that mediate between already existing structures and buildings in their recovery from non-places to highly vibrant places. This includes abandoned underpasses transformed into vivid spaces for outdoor activities, a traffic island turned into a circular arena for artistic interaction, a temporary landmark crowning a highway bridge, and a rundown subway station repurposed as an open-air opera house. The book's concluding chapter, **WHY DON'T WE DO IT IN THE ROAD? ~ New Forms of Engagement in the City**, brings together a wide variety of approaches that highlight the personal as well as collective appropriation and creation of spaces for social and cultural exchange. Everything from the reactivation of empty city plots to self-initiated mobile kitchens, communal wall paintings, interactive public art projects, and urban playgrounds can be found in this chapter. Here, the underlying goal is to revitalize vastly overlooked urban areas, and to encourage the public to see empty space as an opportunity, and not just as a sign of neglect.

We hope that this eclectic collection will foster a basic understanding that this generation of cross-fertilized public spaces—projects that can be adopted and transformed into collective space put to new use by urban planners, architects, and the general public alike—is of paramount importance to the success of the entire public realm and the creation of spatial and communal identity. Public space remains the ultimate arena for investigation, exploration, and articulation of the dense and diverse public landscape we live in.

In our approach to the discussion of public space, this book takes into account several key theses. First, it considers the plural nature of each of us as citizens and individuals living and working in changing places and moving in various real and virtual spaces on different scales and planes. Second, it considers the plural nature of urban life per se (the city or polis is pluralism, as Greek philosopher Aristotle already said in his Politics). Considering these two concepts as one, we advocate for the design of heterogeneous public space that plays a crucial role in intelligently responding to this plurality by embracing the paradoxes that are inherent in the debate of public and collective space.

In this context, the words of American-born Canadian writer and activist Jane Jacobs, taken from her seminal book from 1961, The Death and Life of Great American Cities, which is best known for its powerful critique of urban renewal policies, still hold true in today's discussion of public space and its societal implications: "Cities have the capability of providing something for everybody, only because, and only when they are created by everybody."

Following her line of thought by no means suggests that successful city planning should be based solely on participatory designs processes. Perish the thought, as anyone would quickly agree to who has partaken in seemingly open but all too often tenacious decision-making public processes of this kind. What Jacob's quote reminds us of, however, is first, that all space is social and involves appropriately assigning places to specific social relations. Second, it reminds us that urban planning, which fails to consider the human activity of the city—in all of its inherent complexity, beauty and chaos—can never succeed because by doing so it fundamentally rejects the very essence of what a city is. Every city need to encourage the duality of physical space and human activity, and needs to strive for the diversity that this can create. Cities need consensus as much as they needs conflict as their enabling forces. The interaction at different levels and among different parties may be symbiotic or may be full of conflict, but it is this multiple constitution that is essential to the ultimate survival of the city. Today, urban planners, architects, and other creatives do not need to think and act in oppositional terms when engaging with the community and the design of the city, but instead they can learn from one another, critically and wholeheartedly. The concepts of public space, democracy, and citizenship are ultimately redefined by people through life experience. Some projects will succeed and others will fail in these processes. But in the end, it is the people who apply meaning to public space, whatever and wherever it may be.

CHAPTER 01

ĜIMME SHELTER

PUBLIC ARCHITECTURE AS PLACE-MAKER

The image of the contemporary city is just as diverse as the expectations and desires invested in its often controversial public spaces. Urban planners and architects are constantly confronted and concerned with reviving cities, and have come to address urban quality more and more imaginatively. Prior barriers are coming down in terms of thinking about what public space and architecture can mean. We have come to see that a place worth living in and enjoying long-term must treat its spaces joyfully and spontaneously. This chapter looks at inspiring architectural projects, impermanent as well as permanent, small as well as large, that provide examples of these spaces, including those which are clearly defined as well as inherently unsettled, and those within and beyond city boundaries.

Think for example of Colombian architect Giancarlo Mazzanti's Forest of Hope on the hills of one of Bogotá's shanty towns—a 700 square meter installation comprising green prefabricated dodecahedrons, with 12 surfaces wrapped in steel mesh, offering a light and porous mode of shading. Designed to look like a dense forest canopy, this beacon of hope in a crime-ridden area provides shelter from the sun, but also hosts a variety of activities such as acting, playing, sports, and community gatherings.

Less spectacular in its formal language but equally effective is Atelier Kempe Thill's Urban Activator, which expresses in its specific neutrality a different line of thought in architecture that is both economical and innovative. This podium for open-air festivals on Grotekerkplein in Rotterdam stimulates activities and emphasizes the spatial qualities of a previously run-down and unattractive inner-city square. Even when not in use, the structure offers a spatial surplus.

Also in this chapter are temporary edifices such as Finish architect Marco Casagrande's cocoon-like spatial installation in a highly-industrial region of Taipei, Taiwan. The organically flowing bamboo structure revolves around a central fireplace and is designed as a public forum for visitors. Another beautiful project in this category is Waiting for the River by the Dutch art and architecture collective Observatorium. Observatorium has created a large inhabitable bridge, complete with dormitories, outdoor eating areas, and a bathroom, in anticipation of the newly cleaned and denaturalized Emscher River in Germany, whose waters will soon flow through the surrounding landscape.

An exemplary work of large-scale intervention is the chromatic Merida Factory Youth Movement by Spanish architect Selgas Cano, designed as a large canopy open to the entire city. Its program includes everything from a skatepark to a stage for concerts, theater, and performing arts. A similar work, in this case a floating cloud-like roof with a mixed-used character, can be seen in German architect Jürgen Mayer H.'s Metropol Parasol. This impressive timber structure grows out of an archaeological excavation site and is a contemporary landmark defining a relationship between the historical and contemporary city.

In addition to their timely formal aesthetics, these multifaceted edifices are places for social encounters, created using imagination and experimentation in their planning, design, and management of public space and architecture. The experiences they make possible and the consequences they have in our lives and in our built and cultural environment are of far more importance than their stylistic language or building structure. Independent of their temporal status as impermanent or permanent settings, their lasting impression capitalizes paradoxically on the nature of their ephemeral power, namely the affect and effect they exercise on the liquid sociocultural statistics of our cities. City planners should take these factors into consideration as they may truly be the strongest in the toolbox of current urban planning. In today's world, the evolving and varied needs of increasingly diverse populations cannot be met with single-handed urban planning masterstrokes, but rather require critical endeavors of great elasticity and flexibility.

FOREST OF HOPE

Mazzanti Arquitectos
Altos de Cazucá, Soacha, Colombia, 2011

Underneath a geometric green canopy in the outskirts of Bogotá stands a successful recreation center where local residents practice a variety of sports and academic activities. Placed in a depressed area lacking public infrastructure, this project consists of a series of interlocking modules that can grow and adapt to the needs of the community. The design of the main olive-green canopy evokes a cluster of trees, embedding a prominent symbol of nature and hope within its urban surroundings.

CHAPTER 01 ~ GIMME SHELTER

MARCUS PRIZE PAVILION

BARKOW LEIBINGER ARCHITECTS, PROFESSOR KYLE TALBOTT AND STUDENTS OF THE UNIVERSITY OF WISCONSIN—MILWAUKEE'S SCHOOL OF ARCHITECTURE AND URBAN PLANNING
Milwaukee, USA, 2008

A student-led community design-build project revitalizes a derelict area of Milwaukee. Located on a brown-field site under an imposing highway overpass, the open pavilion becomes a new place to meet, socialize, and hold informal classes. Diminutive and light, the project is the first in a series of pavilions to be built along the parkway. The design of the canopy structure echoes the botanical forms of the local flora, allowing the contemporary project to dialog with its surroundings.

LANTERNEN

ATELIER OSLO & AWP
Sandnes, Norway, 2008

This canopy over a small square in the pedestrian-friendly old town of the city revitalizes the area and offers a multipurpose space for public activities. The site is a meeting point, market, and informal venue for concerts and performances, and it attracts attention from up close and afar. The project reinterprets the iconographic shape of an old wooden house to lure people from a distance. By redefining this traditional typology, a new landmark for the city emerges. In addition to having a recognizable shape, the roof provides an ever-changing experience for daily visitors as it stretches out, capturing the sun, reflecting the clouds, or glowing like a lantern at night. The roof is held up by four groups of sculptural columns, creating a flexible open space for various performances and activities. In some places the tree-like columns turn into benches to help blur the distinction between inside and outside.

14 ∧ CHAPTER 01 ~ GIMME SHELTER

BAB AL BAHRAIN PAVILION

LEOPOLD BANCHINI (BUREAU A) & NOURA AL SAYEH
Manama, Bahrain, 2012

One of the few existing public areas in Bahrain, this project questions what a contemporary public space in the Arab world can look like. Located at the entrance of the Suq, the project belongs to a tight urban structure which benefits from a natural pedestrian network. Existing for just a few weeks, the pavilion reinstates a strong sense of place, redefining the square as a representative public area within Bahrain. The ethereal canopy transforms the existing square into a new shared space, encouraging a debate about its future. In addition to hosting lectures, movie screenings, public interviews, workshops, and a redesign competition for the square, the lightweight, translucent shading fabric modifies users' perceptions of the newly enclosed space and improves its climatic conditions. The reflective thermal screening generates a welcoming microclimate and heavily reduces traffic, allowing the public to reclaim the streets and take part in various communal activities.

MERIDA FACTORY YOUTH MOVEMENT

SELGASCANO
Mérida, Spain, 2011

Skateboarding, rock climbing, dancing, and parkour represent just a handful of the myriad activities supported by this iconic recreation center. Conceived as an expansive canopy open to the city, the colorful and geometric project functions as a dynamic, multipurpose space for sports and outdoor activities. Supported by a series of muscular glowing modules that house internal programs, the canopy protects visitors from the rain and sun. The undulating, translucent roof hovers like a light cloud over the center. One face of the tessellated canopy flattens into a vertical climbing wall, challenging the distinction between building and urban activator.

17

18 ∧ CHAPTER 01 ~ GIMME SHELTER

METROPOL PARASOL

J. MAYER H. ARCHITECTS
Seville, Spain, 2011

A striking addition to Seville's medieval inner city, this technologically groundbreaking project offers a sweeping multilevel series of public spaces. The massive, undulating timber structure weaves across the plaza, providing shade and space for an archaeological museum, farmer's market, and elevated plaza with a panoramic terrace. Transforming an archeological site into a contemporary public landmark and bustling social center, this memorable project cultivates a unique relationship between the historical city and a modern urban expression.

20 ∧ CHAPTER 01 ~ GIMME SHELTER

OPEN CENTER OF CIVIC ACTIVITIES

PAREDES PINO
Córdoba, Spain, 2010

Located near the main railway station, this surreal urban canopy adds fresh character and a sense of scale to the city. The network of colorful, circular parasols varies in height and diameter to create a covered area protected from the weather. Supporting a wide variety of uses, the shaded plaza houses everything from markets to informal yoga classes. Illuminated from underneath, the site remains active throughout the day and night. The tops of the parasols reveal different shades of pastel hues, producing a playful and inviting composition that welcomes visitors from both ground level and a bird's eye view.

22 ∧ CHAPTER 01 ~ GIMME SHELTER

MAIN PLAZA SHADE STRUCTURES

RIOS CLEMENTI HALE STUDIOS
San Antonio, USA, 2009

The design for these shade canopies takes inspiration from San Antonio's tradition of handcraft as well as from its rich multicultural and ethnic history. The aesthetic character of the canopies consists of a series of woven ribbons through the trees. The structural system blends in with the site, supporting a light and airy series of floating, colorful bands that stand out against the green leaves and blue sky. Each canopy produces a large swatch of shade underneath, allowing visitors to stop and refresh until new trees can grow in place of the canopies. The overall look and feel of the project changes constantly, responding to the location of the sun and the angle of the viewer.

PINK BALLS

CLAUDE CORMIER + ASSOCIÉS
Montreal, Canada, 2011

170,000 pink balls suspended high into the air cover 1.2 kilometers of one of Montreal's main thoroughfares in a vibrant and playful canopy of color. Three different sizes of plastic balls in five subtle shades of pink are strung together with bracing wire, crisscrossing the street and stretching through tree branches at varying heights. The installation deployed in nine distinct sections, each displaying its own unique pattern. The resulting spirited motifs range from dense to open and airy, reflecting the street's many moods. In addition to producing a delightful visual impact, the artificial pink foliage modulates the daylight, generating an intimate and shifting atmosphere for the pedestrians ambling below its whimsical form.

WATER CATHEDRAL

GUN ARCHITECTS
Santiago, Chile, 2012

The winning proposal for the MoMA Young Architects Program International produces a large, horizontal urban nave for public use. The structure comprises numerous slender, pyramidal components designed to capture water. These dramatic forms hang or rise like stalactites and stalagmites from a minimal steel framework that varies in height and concentration. Water drips at different frequencies from these hanging elements, acting as a visually compelling climatic interface for cooling visitors beneath the canopy. Concrete benches in the shape of stalagmites are strategically placed below the streams of water, encouraging people to gather and interact with the installation.

27

CANOPY

UNITED VISUAL ARTISTS
Toronto, Canada, 2010

Inspired by the experience of walking through the dappled light of a forest tree canopy, this tessellated 90-meter-long light sculpture spans the front façade of a prominent building in Toronto. The permanent installation is made from thousands of identical modules, organized in a non-repeating growth pattern. Their crystalline form, abstracted from the geometry of leaves, nurtures a feeling of nature within an urban context. A combination of daylight and artificial light sweeps through the work, referencing the activity of cells within a leaf, leaves within a forest, or a city as seen from the air.

ORIGIN

UNITED VISUAL ARTISTS
New York, USA, 2011

This large-scale responsive LED sculpture produces a futuristic space for public gathering. Hedged between the two bridges on Brooklyn's shore, the 10 × 10 m cube of light both disrupts and reflects the city, eliciting an emotional reaction from those that enter its realm. The open framework edged with light maintains a lively dialog with its surroundings, inviting visitors to view their city through a layered network of gridded perspectives.

LUMINOUS FIELD

LUFTWERK
Chicago, USA, 2012

This 10-day-long public art project transformed Chicago's Millennium Park into a digital canvas of light and geometric form. The public, site-specific interactive video and sound installation capitalized on the reflective properties of Anish Kapoor's iconic Cloud Gate sculpture, turning it into a canvas for a choreographed light show. Using ten projectors, the ephemeral project merged video and light with material, surface, structure, and sound to offer an immersive and collaborative spatial experience.

[C]SPACE DRL10 PAVILION

NEX ARCHITECTURE
Bedford Square, London, UK, 2008

This structurally innovative pavilion employs a radical use of material to achieve its continuous formal expression. Fibre-C, a thin reinforced cement panel, gives the project a striking presence and arouses curiosity from a distance. Upon closer interaction, its sinuous, curving logic and integrated programmatic functions are revealed. As visitors move around the pavilion, the surface varies from opaque to transparent, producing a stunning three-dimensional moiré effect. The surface cultivates a feeling of enclosure while also providing an active pedestrian route and gathering space, blurring the distinction between inside and outside.

RESEARCH PAVILION

ICD/ITKE
Stuttgart, Germany, 2011

This temporary bionic research pavilion made of wood is the result of a collaboration between the Institute for Computational Design (ICD) and the Institute of Building Structures and Structural Design (ITKE). The project explores how the biological principles of a sea urchin's plate skeleton morphology can translate into a discernible architectural logic. Realized by means of computer-based design, simulation, and fabrication methods, the pavilion achieves its complex geometry with high-performing, lightweight structures that expand and contract to create entrances and skylights. Digitally designed and fabricated by a robot, this striking pavilion demonstrates the untapped potential for creating highly meaningful public spaces through the use of cutting-edge technology.

LIVING PAVILION

BEHIN + HA
New York, USA, 2010

Imagining a future where nature returns to the city, this low-tech, low-impact summer installation employed an arched lattice of 437 milk crates as the framework for growing a planted urban pavilion. Creating a synthesis of form, structure, light, and life, the pavilion's interior surface was covered with hanging plants that provided a naturally cooled and shaded gathering space beneath. At the end of the season, the pavilion's modular design allowed for easy disassembly and distribution of the planted milk crates, which went to homes, public places, and community gardens across the New York area. By using a common object in an uncommon way, the project added a new dimension to the urban experience, embodying and communicating an ethic of reuse, recycling, and repurposing.

36 CHAPTER 01 ~ GIMME SHELTER

37

CICADA

MARCO CASAGRANDE
Taipei City, Taiwan, 2011

An organic void emerging out of the mechanical texture of modern Taipei, this bamboo cocoon functions as a mediator between modern man and reality. When entering the outdoor pavilion one is engulfed by the soft and tranquil interior, and the surrounding city disappears. Removed from considerations of time and space, modest black stools are sprinkled across the grey gravel, providing opportunities to sit, reflect, and gather within this serene temple.

FABLAB HOUSE

IAAC–INSTITUTE OF ADVANCED ARCHITECTURE OF CATALUÑA
Barcelona, Spain, 2010

Part of an international competition for universities to develop sustainable homes, this unique prototype doubled as a popular public space during its exhibition at the US Solar Decathlon. Visited by over 20,000 people and awarded the People's Choice Prize, the lifted form of this organically shaped house generated an impromptu shaded patio, ideal for communal gathering and socializing.

CHAPTER 01 ~ GIMME SHELTER

OPEN-AIR-LIBRARY

KARO *
Magdeburg, Germany, 2009

This informal and distinct library is based on the designer's temporary Open-Air-Library that existed for only two days on an industrial site in East Germany. Five years later, a resident-led initiative transformed the concept into this permanent incarnation. An active collaboration between the designers and local residents, the 24-hour library now offers 30,000 books. Available to all and lacking the bureaucracy and limited opening hours of its more formal counterparts, this flexible library rethinks the traditional, and often overly strict mode of the library, while adding a much-needed public space for local residents.

BLACK PIG LODGE

HEATHER AND IVAN MORISON
London, UK, 2012

This modest pavilion invites visitors to shelter within a glistening chamber of polished coal sourced from a working mine in the Neath Valley of Wales. The outside of the structure resembles a rough bunker based on the hand-built vernacular style found in the mining region. The inside presents a smooth, manufactured, and polished surface, an ideal space for ceremony and gathering. Drawing on global folklore and the dark mythology of the television series Twin Peaks, the project stands as a relic from an imagined future. Using a specially developed method of casting coal, the exterior applies a cast wooden shingle pattern set within a gridded steel framework. A large table runs down the center of the interior encouraging dialog and group activities.

BA_LIK—SUMMER STAGE AND EXHIBITION PAVILION FOR BRATISLAVA

VALLO SADOVSKY ARCHITECTS
Bratislava, Slovakia, 2009

Set in one of Bratislava's historical squares, this eye-catching urban intervention applies methods of flexibility and mobility to reactivate a previously neglected public square. Lime green on the inside and white on the outside, the pavilion comprises five elements mounted on wheels that compact and expand based on the needs of the event taking place. During the summer months, the space can be used for various cultural activities ranging from theater performances and concerts to art exhibitions. In between events, the pavilion doubles as modern city furniture, giving the square a young, contemporary identity.

URBAN ACTIVATOR

ATELIER KEMPE THILL ARCHITECTS AND PLANNERS
Rotterdam, Netherlands, 2009

This project reactivates a prominent city square that had fallen into disuse due to several decades of neglect. The construction of this small concrete and steel theater pavilion animates the square both programmatically and spatially, filling the urban vacuum within the city fabric. A targeted and powerful gesture, the 40-meter-long structure forcefully separates the square and canal from one another in order to enhance their respective spatial legibility. The podium occupies almost the entire western side of the square, resulting in an enhanced framing of the space and sense of intimacy. The structure itself, conceived as an open and transparent volume, maintains a visual connection between square and water, avoiding spatial constriction. The resulting object operates as a successful public activator within the city, defining spaces while simultaneously inspiring openness in between them.

PEDRO ALMODÓVAR'S MONUMENT

SERGIO GARCÍA-GASCO LOMINCHAR
Calzada de Calatrava. Spain, 2009

This monument to Pedro Almodóvar links the filmmaker's birthplace with his cinematographic work. Standing as a reminder of the strong influence that his culture and native landscape have on his films, the striking project frames a piece of Almodóvar's Spanish skyline. The stepped form of the textured red concrete structure is inspired by the format of a camera, and encourages accessibility to the monument for use as a meeting point or site for events. Resting atop a modest hill, the project can be seen from the main road into town, becoming both a beacon and a source of pride for the area.

FREYA AND ROBIN

STUDIO WEAVE WITH PETER SHARPE, KIELDER ART AND ARCHITECTURE PROGRAMME; PRICE AND MYERS ENGINEERS, AND MILLIMETRE
Northumberland, UK, 2009

Two structures placed on the banks of an English waterway provide stopping points for visitors walking or cycling along the lakeside path. These visible markers embrace the man-made nature of the surrounding water and forest. The intricate wooden hut and the golden cabin face each other across the lake, establishing a visual dialog between the architecture and its occupants.

47

WINNIPEG SKATING SHELTERS

PATKAU ARCHITECTS
Winnipeg, Canada, 2010-2011

A delicate cluster of temporary structures provides shelter for ice-skaters against the harsh winter winds. Fabricated from two layers of flexible plywood, the intimate shelters accommodate just a few people at a time. Inside, a timber floor and plywood seating engulf the visitor, exuding a sense of warmth and comfort. Together, the shelters create dynamic solar and wind relationships that shift according to specific orientation, time of day, and environmental circumstances. Moving gently in the wind and floating precariously on the surface of the frozen river, the fragile and tenuous nature of the structures makes those sheltered by them supremely aware of the inevitability, ferocity, and beauty of winter on the Canadian prairies.

NOUN 1. UNAVAILABILITY — THE QUALITY OF NOT BEING AVAILABLE WHEN NEEDED

GARTNERFUGLEN ARKITEKTER
Telemark, Norway, 2012

This mobile fisherman's hut with walls of ice engages a simple, foldable timber frame for easy relocation and storage. The walls are filled with panels of ice from the lake and function as a buffer against the harsh winter winds. A pocket of heated tranquility during the winter, the bare chicken wire walls become a support for climbing plants and vegetables during the summer, transforming the pristine shelter into a transportable garden gazebo.

50 CHAPTER 01 ~ GIMME SHELTER

EVOLVER—ENTRÉE ALPINE PANORAMIC STRUCTURE

ALICE (ATELIER DE LA CONCEPTION DE L'ESPACE) AT ECOLE POLYTECHNIQUE FÉDÉRAL DE LAUSANNE
Zermatt, Switzerland, 2009

This striking inhabitable sculpture was erected for the Zermatt Chamber Music Festival. As an architectural artifact, the project intervenes spatially against the pristine panoramic backdrop. In an effort to capitalize on the site's extensive and impressive views of the surrounding landscape, the project sits strategically next to Lake Stelli at an altitude of 2,536 meters. With the structure consisting of a succession of 24 rotating frames supported by an enclosed area for visitors, as one traverses the space a concealed but uninterrupted 720° path choreographs a spectacular panoramic journey to the wilderness beyond. Oscillating below and above the distant horizon, ground and sky have been realigned into a fluctuating vista that culminates where it starts—a loophole in the sky.

GROUND FOLLY

ISLAND-CITY FOLLY WORKSHOP
Fukuoka, Japan, 2009

The result of a student workshop led by Toyo Ito, this whimsical form integrates a series of concealed spaces for hiding, gathering, relaxing, and exploring. Appearing like a round floating mass of earth, different cutouts offer a range of spatial experiences that fluctuate between light and dark and merge into and through one another. The interlocking spaces harness elements of surprise and collaboration, bringing back the forgotten fun and wonder of childhood.

TRAIL HOUSE

STUDIO ANNE HOLTROP
Almere, Netherlands, 2009

Part of the exhibition "Unknown Territories" by the Museum De Paviljoens, this open house turned pavilion uses fragments of the existing outdoor paths and trails to define its spatial layout. Curling, bending, splitting, and opening onto the landscape, the project functions as a type of objet trouvé and landscape element, defined more by its relationship to the outdoors than by its architectural function. A curve, a dead end, a bifurcation, and a hideout all represent unique spaces actively relating to and in dialog with the surrounding landscape.

ARBORETUM

RINTALA EGGERTSSON ARCHITECTS
Gjøvik, Norway, 2011

Part of an institution for juvenile asylum seekers, this austere project serves as a contemplative refuge for children to take part in meaningful outdoor activities. Composed of a small garden of trees selected from all the habitable continents of the world, the arboretum establishes a connection between different geographies, past and present. The trees act as a physical symbol of the potential for life and growth in new soil. The partitioned architecture of the arboretum derives its logic from a triangulated model of the earth, demonstrating the interrelatedness of different people and cultures.

INTO THE LANDSCAPE

RINTALA EGGERTSSON ARCHITECTS
Seljord, Norway, 2009

For this student-led project, three elegant structures appear around a lake in southern Norway. Inspired by the local stories of a mythic sea serpent, the structures offer stopping places for travelers and tourists and meeting points for local residents. Situated on the northern side of the lake atop a hill, the first project enjoys a scenic view over the lake and valley. This element comprises a group of six spaces that form a circle at the edge of the forest. The second component, a smoke sauna, sits in a bay on the southern side of the lake near the road. The building acts as a protective wall, creating a private and intimate setting for visitors. The final piece of the project, the fishing camp, rests in the center of the lake, offering a bridge for easier communication, a roofed shelter, and a fireplace.

57

58 CHAPTER 01 ~ GIMME SHELTER

WAITING FOR THE RIVER

OBSERVATORIUM
Emscher River, Germany, 2010

This inspired project consists of a 125-foot-long inhabitable bridge, complete with dormitories, outdoor eating areas, and a bathroom. Constructed in anticipation of the newly cleaned and renaturalized Emscher River, the zigzagging project symbolizes the anticipation of better times and a better environment. By building a covered bridge for a river that is not yet there, visitors are invited to stay 24 hours and dream about the impending transformation of the landscape. The project, made from reclaimed timbers, functions as an inverted sightseeing destination, constructed in advance of the very thing it's meant to help the public see. The preparation of the transitioning landscape becomes the main spectacle drawing people to this isolated piece of architecture, which eagerly waits for a river to pass by.

CHAPTER 01 ~ GIMME SHELTER

TVERRFJELLHYTTA— NORWEGIAN WILD REINDEER CENTRE PAVILION

SNØHETTA
Hjerkinn, Norway, 2011

Set on a spectacular site on the outskirts of Dovrefjell National Park, this elegant information pavilion provides shelter for school groups and visitors. Home to wild reindeer herds, musk oxen, arctic foxes, and a variety of botanical species, modern tourism and recreation continue to shape this cultural landscape. A wooden core placed within a rectangular frame of steel and glass, the building design establishes an engaging dialog between the organic and the rigid, the natural and man-made. Shaped like a massive rock or piece of ice eroded by the natural forces of wind and water, the shape of the interior forms a protected and warm gathering place while still preserving a visitor's access to the breathtaking scenery. The shelter's simple yet provocative form redefines local building traditions and produces an inspiring place to enjoy the mystic and ancient landscape.

CHAPTER 02

CONSTANT GARDENER

GREEN SPACE IN THE CITY

We have heard it countless times before: within the next couple of decades the majority of the world's population will be living in towns or cities for the first time in history. One could argue that the relationship between humans and nature is therefore in danger of becoming marginalized, reduced to only an interaction of luxury. This chapter, in contrast, displays various projects that reflect our inherent desire to go back to nature, not by turning away from the city, but by deliberately staying within the city limits. Urban gardening, as many call this contemporary phenomenon of cultivating green spaces in the city, does not intend to leave the city behind, but rather proposes to enrich it by incorporating nature. Idealized terms such as nature or garden endure with their connotations of respite from the city's rigors, but new layers are added to their definitions that also involve urban themes. This development actually reflects a new and refreshing understanding of urbanity today, one in which classic dichotomies begin to falter. Connotations of polarity begin to weaken when pinning words such as city and country or culture and nature against each other.

An example of the natural landscape taking over in a public space is shown in the climbing garden in Bilbao, Spain, conceived by the New York–based landscape and urban designers Balmori Associates. The garden engages a horizontal plaza with a rising vertical plane of steps in undulating lines of different textures and colors. Another example of bringing biodiversity into an urban context is The Green Cloud by TeMA Urban Landscape Design. This lush garden, located at the center of an industrial area in Israel, is planted with sculptural trees around its perimeter. A biological pool with a diverse group of waterlilies and fish defines its contemplative center.

While The Green Cloud remains enclosed within an already existing building structure, Spanish architect ACXT uses landscape design and a precise understanding of local topography as an intelligent way to recover a derelict area. Galindez Slope and Pau Casals Square disintegrate a natural, physical barrier in the city. Turning the rocky embankment of mountain slopes in the peripheral area of Bilbao into a connecting element and public space, planes of different material are cut into the rock, creating new gently sloping stairways that connect two levels of this district.

Another example of improving the quality of the surrounding urban space with a landscaping element is shown in the Miami Beach Soundscape by the Dutch urban design and landscape architecture firm West 8, adjacent to the New World Symphony building by Frank Gehry. The new multi-use 2.5-acre urban space in the cultural and civic heart of Miami Beach features extensive multimedia equipment and interlacing pathways of changing widths that circulate in a mosaic-like network. The space serves as both an oasis in the city and a gathering place for social events.

The designs in this chapter rethink nature's urban manifestations and create surprising parks and gardens that contribute to the overall cityscape. These green zones act as lungs within the organism of the city, and also fulfill a variety of purposes that go way beyond the traditional Garden of Eden hybrids or nineteenth-century style municipal and people's parks. They still invite us to stroll and rest, to contemplate and admire nature, and they still offer space for numerous activities, from public demonstrations to collective celebrations. But they are also deliberate in their role as part of greater movements in urban planning that aim to recover, reclaim, and reconnect isolated pieces of land within the urban and suburban fabric.

THE CITY DUNE

STIG L. ANDERSSON
Copenhagen, Denmark, 2010

On the harbor of Copenhagen, an area widely criticized for its low quality office buildings and limited public areas, this inviting urban space ties the new Swedish SEB Bank & Pension headquarters together with the surrounding city. Drawing inspiration from the sand dunes of the Scandinavian landscape, the undulating and striated plaza design ensures the mobility of pedestrians and cyclists. The contour of the folded white terrain offers a variety of routes suitable for everyone from skaters to those in need of special assistance. The shifts in terrain, vegetation, time of day, and users ensure that each visit will be different. Water atomizers, emitting moist air spread by the wind, add to the experience of walking through a lush swatch of Scandinavian nature in the middle of the city.

PARK MADRID RÍO — PORTUGAL AVENUE

BURGOS & GARRIDO/PORRAS LA CASTA/RUBIO & ÁLVAREZ-SALA/WEST 8
Madrid, Spain, 2011

A small part of a greater movement to reclaim Madrid's riverbanks, this urban park recovers a section of one of the most important roads leading into the city center for public use. By relocating traffic lanes and parking into an underground tunnel, the cherry blossom—inspired garden offers an extensive public space to local residents. The abstraction of the cherry blossom into a key design element manifests in a number of ways. Ranging from the planting of different kinds of cherry trees to the gestural reinterpretation of the Portuguese paving, each gesture encourages public outreach and connection with the surrounding city.

ATLANTIC PARK

BATLLE I ROIG ARQUITECTES
Santander, Spain, 2008

Situated between two roads that define its perimeter, this long and narrow site engages an extant watercourse and its native plant life as the primary design feature for a new public park. Part of a large tract of open space on the outskirts of the city, the main entrance offers vehicular access to the park through a grove of trees that culminates in a lookout point over a green amphitheater. The park accommodates two levels of intensity, one for mass during large events and the other for more intimate walks and outdoor gatherings. The organizational strategy for the site reproduces the revised morphology of the Atlantic Ocean, with a stylized reproduction of its outline generating the paths around the perimeter and the ocean itself becoming the reserve for the existing colony of reeds. The outlines take the form of terraced slopes planted with vegetation that transition into steps, ramps, and amphitheaters across many levels.

TEMPELHOFER FREIHEIT

Berlin, Germany, 2010

An abandoned airport turned vibrant park, this project provides an expansive public oasis within Berlin's urban city center. The present form of this open space is a transitional stage and starting-point for an ongoing public development process. This site—once used only for airport operations—will be developed, as a multi-use, structured urban parkland that will gradually arise over the next few years. The current informal layout of the park is an ideal destination for outdoor activities ranging from picnics and sunbathing to a variety of outdoor sports and community projects. One part of the park hosts the Allmende-Kontor, an impressive urban agriculture and community garden initiative. Thanks to this successful reclamation, the land now functions as one of the largest urban parks in the world.

69

MIAMI BEACH SOUNDSCAPE

WEST 8 URBAN DESIGN & LANDSCAPE ARCHITECTURE
Miami Beach, USA, 2009-2011

Establishing a new precedent for parks in Miami Beach, this green urban project exudes a soft and shady intimacy, making it a successful attraction of the New World Symphony Building. The park reflects the spirit and vitality of the vibrant city and cultivates a range of day and night uses. A projection wall on the adjacent symphony building offers an ideal canvas for video artists to share their work with the public outside the confines of a traditional museum experience. The undulating topography is visually reinforced by a mosaic of meandering pathways, pergolas, and seating walls that encourage informal gathering. Veils of palm trees conceal and reveal views, further reinforcing the experience of being within an extensive oasis. A unified expression of recreation, pleasure, and culture, this park merges music, design, and urban planning to cultivate an inviting and memorable outdoor experience.

GENERAL MAISTER MEMORIAL PARK

BRUTO
Ljubno ob Savinji, Slovenia, 2007

This park, dedicated to General Maister and the soldiers of the northern border, comprises an abstract three-dimensional space where paths lead around geometrically cut grass crests. Standing as an abstract representation of the crest where Maister's soldiers fought in 1918, a supporting wall lined with bronze sticks forms a buffer between the park and adjacent road. Each stick bears the name of one of the soldiers who fought for the region. The symbolic composition ends with an abstract life-size bronze figure of a horseman. The triangulated concrete memorial serves as a multifunctional elevated retaining wall while also offering unique resting places and lookouts for visitors to contemplate the historical site.

CHAPTER 02 ~ CONSTANT GARDENER

GALINDEZ SLOPE AND PAU CASALS SQUARE

ACXT

Bilbao, Spain, 2010

Located on a rocky embankment on the periphery of Bilbao, this plot stood as an isolated piece of land prior to development, dividing the surrounding city both physically and socially. The naturally sloping topography is enhanced by the project's use of triangular-shaped inclined planes. These triangular pieces are formed out of various materials ranging from existing rock to multicolored vegetation and concrete. All the elements in the project, including stairs, seating areas, and public toilets, integrate into this faceted topography, reactivating the area and enhancing connection and interaction through a series of interlocking folds.

MATHILDEPLEIN

BURO LUBBERS LANDSCAPE ARCHITECTURE & URBAN DESIGN
Eindhoven, Netherlands, 2009

This new public square offers a feeling of peace and quiet in Eindhoven's hectic city center. A pergola overgrown by wisteria and roses offers passersby a glimpse into the tranquil, green atmosphere. Allowing residents a place to escape the intensity of urban life, the square acts as an intimate enclave with its own distinctive identity. Elongated Corten steel planters create a rhythmic striped pattern across the plaza, resulting in alternating open and closed spaces. These stripes vary in length, width, and height to integrate wooden benches and bicycle stands.

GARDEN FOR A NURSING HOME

CABALLERO+COLÓN DE CARVAJAL
Madrid, Spain, 2009

This graphically landscaped garden finds its beauty in the balance between man-made and natural elements. The distribution and design of the plants and paths enhances that contrast, reading as a kind of enlarged graffiti. A series of winding shapes in different colors establishes a clear distinction between vegetation, drainage, and general circulation. Choosing plants with high resiliency and low water consumption in addition to integrating as many recycled materials as possible, the garden achieves a visually pleasing and environmentally conscious space for hosting visitors and local residents.

THE GARDEN THAT CLIMBS THE STAIRS

BALMORI ASSOCIATES
Bilbao, Spain, 2009

This alluring garden meanders up a large stair, branching out into undulating lines of shifting textures and colors. Envisioned as a dynamic urban space, the project evolves throughout the seasons. The lush plants cascade down the steps, as though the garden was flowing or melting. In a single, sinuous gesture, the unusual planting conveys a visual story of landscape taking over architecture. The garden transforms the perception of the stairs and the public space for its users. It exudes contrast and mystique, both in terms of the vibrant color range between native and exotic plants and flowers as well as in the distinct textural differences between grass and pavement. Evocative of the famous Spanish Steps in Rome, the garden not only accommodates a visitor's ascent and descent, but also offers space and a reason to linger and reflect.

79

80 ♀ CHAPTER 02 ~ CONSTANT GARDENER

SENSATIONAL GARDEN

NABITO ARCHITECTS
Frosinone, Italy, 2011

This playful garden of discovery represents the starting point of a larger master plan to renew and integrate the public spaces and services of a residential Italian neighborhood. Filling the social void with an explosive, whimsical, sensorial, and interactive garden maintains the feeling of a personal living room within the public realm. The project remains in a compelling state of tension between artificial and natural elements, renewing the social sustainability of the forgotten site and city simultaneously. Invited into an always changing scene, visitors enjoy the sensation of discovering different spaces with similar characteristics. The five human senses comprise the main theme driving the material composition and vegetation found in the space, helping users relate to themselves, their surroundings, and their neighbors within a single garden.

SQUARE DES FRÈRES-CHARON

AFFLECK + DE LA RIVA, ROBERT DESJARDINS & RAPHAËLLE DE GROOT
Montreal, Canada, 2008

Composed of a series of circular and cylindrical forms, this public square establishes a dialog between a garden of wild grasses and the remnants of a seventeenth-century windmill. Complementing these minimalist gestures, the lighting concept reacts to the changing seasons. Located at the crossroads of two historic streets in Montreal, the square stands as part of a network of public spaces organized along an important thoroughfare that links the Old Port to the contemporary city center. This entirely new public amenity appears amidst a context that dates back more than 150 years. Built as a response to the urban revitalization of a disaffected industrial sector, the plaza provides public identity, civic pride, and generous outdoor areas for year-round use. The square applies an approach of contrast and connection to combine a prairie wetland with the surrounding city, raising public awareness of the history and geography of the site.

PLAZA EUSKADI

BALMORI ASSOCIATES
Bilbao, Spain, 2011

This oval plaza facilitates a meandering passage between the old city and the new center of Bilbao. Linking two historical parks, the tree-lined project establishes a direct central path through the city while also generating a lively public space for gathering and leisure. The sinuous landscaping incorporates three public pockets with recycled rubber seating that hook onto the sides of the main path. Each pocket maintains a different character and function: a reflective amphitheater, an ottoman seating section, and a garden area with a selection of flowering shrubs and trees. Introducing various grass species, clover, and wildflowers, the plaza operates as both an efficient thoroughfare and an urban oasis for lingering and exploration.

THE GREEN CLOUD

TEMA URBAN LANDSCAPE DESIGN
Herzelia, Israel, 2011

Located at the center of an industrial park, this public oasis within a private corporate complex offers a lush and contemplative garden space for visitors. Boasting 5,430 plants of 98 different species and varieties, the perimeter of the cloud has been planted with sculptural trees that shade its outer limits. The center of the project transforms into a serene pool filled with waterlilies and fish. A long bench flanks the biological pool, enjoying the shade of a row of mulberry trees and encouraging passersby to stop and reflect. The connective paths move from north to south and east to west, referencing the company's branding image of the compass. The paths are enhanced by the use of different materials including cast-in-place terrazzo. The entire project grows above a parking structure and is mostly irrigated by the excess of water channeled from the nearby air conditioning systems. The rich planting variety acts as a successful magnet, bringing the public back into the private realm.

CHAPTER 03

WALK W8TH ME

MODES OF SPATIAL MOBILIZATION

The notion of mobility is currently being discussed across many disciplines. From social sciences and cultural studies to art, architecture, and urban planning, new dynamic rhetoric surrounding movement and mobility is being used. Through the lens of mobility and its multiple references, the way we think about how society unfolds is explored, from the simple movements of things and people and the formation of mobs and crowds to socio-economic mobilities and migrations that can include the flow of information, images, and ideas, along with the diverse and increasingly networked movements that constitute our contemporary world and its conditions of freedom and governance. Against this large backdrop, this chapter brings together projects that facilitate and explore new transitory spaces such as boardwalks, passages, shortcuts, routes, bridges, and spectacular viewpoints, all overcoming the passive confines of the everyday built environment. These projects open up entirely new perspectives on city and landscape. Such novel practices also reflect a new understanding of traffic patterns in urban planning.

A look at the Benidorm Seafront project by the Office of Architecture in Barcelona reveals how an urban landscape along a seascape can become an identifying element that sets an area apart from similar places. Here, the artificial landscape elegantly works with the constraints of the required width of a seaside promenade, making the form expand to larger areas with benches and places to relax. On top of that, the design serves different functions; while the colored upper level invites visitors to stroll along the path, the bottom curves pour into a wooded boardwalk for runners and beach-goers. Less permanent but equally upbeat is Marseille-based artist Gaëlle Villedary's Red Carpet, which rolls through the provincial village of Jaujac in southern France as part of its 10th anniversary of art and nature trail program. For this project, Villedary mapped out a winding green carpet through the streets of the entire village. The carpet not only leads to the outer limits of town and into nature, but also brings nature inside the city walls, harmonizing the village with its surroundings. Stylistically related is Dutch artist Henk Hofstra's The Blue Road in the small town of Drachten, Netherlands. By painting 1,000 meters of road blue, we are reminded of the waterway that used to be where the road is now, and the phrase "Water is Life" is written in eight-meter-high lettering across it.

A landmark of a different kind in treating the topic of water is the Lusatian Lakeland Landmark in Germany, where the largest artificial lake landscape in Europe is emerging. Here the mighty craters left behind where huge excavators once lifted lignite out of the earth are now being flooded. Right in the center is the landmark, made from rust-colored Corten steel. It is intentionally reminiscent of the industrial origins and history of the area, an unmistakable and tangible symbol of the future that provides a panoramic view of the lake landscape. Another example of a spectacular pathway leading to a comparably spectacular viewpoint is the Trollstigen National Tourist Route Project by Norway-based architecture firm Reiulf Ramstad. Characterized by clear and precise transitions between planned zones and the natural landscape's majestic mountains and falling waters, the architecture here creates a series of designs that speak to and magnify the unique spatiality of the site.

The concept of built space is questioned here by consciously soliciting the powerful language of architecture as a procedural experience more than as a physical structure. These new spaces engender new forms of sociability that both replace and augment basic interaction, including face-to-face communication, situations of co-presence, and identification. Personal as well as collective movements through an increasingly fragmented cityscape therefore become reunified on the basis of both intuitive and playful orientations. In terms of how urban planners approach the construction and integration of space, the projects shown in this chapter accommodate new flows and dynamically alter existing paths. Here, the journey is the reward.

RED CARPET

GAËLLE VILLEDARY
Jaujac, France, 2011

This elegant installation takes place in the heart of a scenic, Parisian village. Celebrating the 10-year anniversary of the Art and Nature Trail, the meandering project, composed of 168 rolls of lawn, functions as a type of symbolic red carpet. Connecting the town and its inhabitants with the surrounding valley, the fleeting installation materializes as a winding green ribbon of vegetation. This lush garden path flows over the cobblestones, winds up and down stairs, and finally glides into the center of the streets, guiding the curious and willing back into nature.

BANYOLES OLD TOWN REMODEL

MIÀS ARCHITECTS
Girona, Spain, 2012

Part of a greater urban renewal program to transform the old town of Banyoles, this project reintroduces water as an important element to the redesign. Conforming to the medieval layout and architecture of the region, the scope of this intervention uncovers and reactivates hidden water canals buried under the historic substrate of the town. In order to avoid disrupting normal functions and circulation routes, these waterways remain only partially reactivated, establishing a coherent discourse between past and present while forming dynamic visual compositions across the town's narrow streets and plazas.

BICYCLE PATH_A TRACK PRINTED ON THE MEMORY

GLOBAL ARQUITECTURA PAISAGISTA & P-06 ATELIER
Lisbon, Portugal, 2009

Part of the municipality of Lisbon's expansive cycling network, this experimental project capitalizes on the proximity of the city's harbor and the Tagus River to develop a unique bicycle route. Working with the heterogeneity of spaces and environments mixed with the proximity of several industrial and monumental sites, the project finds a common ground and produces a defined public image. The design lays down a reversible and graphic bicycle trail over the memory of the river bank, the city, and the river itself in order to minimize conflicts with other modes of mobility and to imprint an unmistakable route upon the landscape. Interpreting the clarity of its linear form with a system of signs, impressions, and incisions on the vast mosaic of preexisting and added surfaces, communication, movement, and experience become key aesthetic attributes for negotiating this spirited bicycle path.

∞ CHAPTER 03 ~ WALK WITH ME

97

THE BLUE ROAD

HENK HOFSTRA
Drachten, Netherlands, 2007

This imaginative project develops an eye-catching and humorous public thoroughfare through the creative application of road paint. Cheerful and high contrast, the intervention add a sense of spontaneity, whim, and color to the public domain. By simply engulfing the busy street and everything in its path in sky blue paint, the project achieves a cartoonesque two-dimensionality that presents a surprising, simple, and fun solution for reactivating our urban context.

98 ∞ CHAPTER 03 ~ WALK WITH ME

BOULEVARD OF STARS

ART+COM & GRAFT
Berlin, Germany, 2010

Channeling Berlin's long history in film and television, this urban red carpet creates a permanent public space for honoring the profession's brightest figures. Situated next to Potsdamer Platz, home of the Berlinale annual film festival, the project revitalizes a prominent traffic island into a promenade for the public to celebrate the legends of the German film industry. The design of the boulevard emphasizes interaction between the visitors and celebrities, featuring everything from the red carpet to the cameras and spotlights. Abstractly represented cameras bring the celebrities to life, producing a hologram likeness hovering above their respective star. Visitors pose next to the floating image of the celebrity and have their picture taken with them. The sight of people posing with a holographic celebrity only visible through the stargazer's viewfinder makes visitors a crucial part of the interactive spectacle. This living, growing urban installation views memory as a form of communication and interaction between the celebrated and their audience.

100 ∞ CHAPTER 03 ~ WALK WITH ME

SEAFRONT OF BENIDORM

OAB—OFFICE OF ARCHITECTURE IN BARCELONA
Benidorm, Spain, 2010

The winning competition entry for remodeling a 1.5-kilometer-long promenade in Benidorm, this vibrant and undulating design connects the town to the sea. Supporting a range of public activities, the organic lines of the promenade, reminiscent of ocean waves, generate an ensemble of honeycomb surfaces that mix light and shadow. A series of convex and concave layers gradually construct a set of platforms and levels for play, meeting, leisure, and contemplation. Eliminating architectonic barriers, this colorful project acts as a complex and provocative transitional strip between the city and beach. The layout engages a system of intersecting curvilinear braids woven together to generate dynamic platforms for public gathering that enhance the experience of the waterfront.

102 ∞ CHAPTER 03 ~ WALK WITH ME

DOVER ESPLANADE

TONKIN LIU
Dover, UK, 2011

Harnessing the architectural language of the city's geographic identity to inform its design, three site-specific sculptural waves bring an interactive dynamism to the waterfront. The first piece, Lifting Wave, appears as a repeated formation of ramps and staircases made of precast white concrete that undulate to connect the boardwalk with the lower shingle beach. The Resting Wave, a retaining wall that runs the length of the esplanade, offers seating sheltered from the wind. The shifting system of precast white concrete blocks tilts back and forth in convex and concave forms, generating a textured surface similar to the sedimentary strata layers of Dover's White Cliffs. The final element, Lighting Wave, consists of a line of white columns with artwork that complements the sweeping form of the sea wall. These columns rise and fall like froth on the crest of a wave, while interactive LED lights add a heightened sense of movement and delight to the seafront experience.

104 ∞ CHAPTER 03 ~ WALK WITH ME

SIMCOE WAVEDECK

WEST 8 URBAN DESIGN & LANDSCAPE ARCHITECTURE + DU TOIT ALLSOPP HILLIER
Toronto, Canada, 2009

This playful timber topographic structure undulates along Toronto's Central Waterfront, providing a public gateway between city and lake. Inspired by the sinuous contours of the Canadian shoreline, the simple wave structure uses a consistent palette of materials and details. The identity of each wave derives its form from the unique activities it accommodates. Functioning as both a piece of art and a gathering space, the urban dock offers great flexibility in terms of public use. The stairs act as an informal amphitheater and the varying height of the deck allows visitors to enjoy different vantage points and ultimately different experiences of the lake. Two large swells feature slender stainless steel railings that differentiate the artistic portions of the deck from the public areas, while also helping wandering visitors negotiate the slopes. The 30-meter bench acts as an elegant public buffer between water and land.

105

THE LONGEST BENCH

STUDIO WEAVE
Littlehampton, UK, 2010

This whimsical project serves as the longest bench in Britain, seating over 300 people. The structure sinuously travels along the promenade, meandering around lampposts, bending behind bins, and ducking down into the ground to allow access to the beach. Like a seaside boardwalk, the project rests gently on its habitat, adapting to its surroundings while also connecting and defining them. Fabricated from thousands of tropical hardwood slats, the reclaimed timbers intermingle with splashes of bright color wherever the bench wiggles, bends, or dips. Two bronze-finished steel monocoque loops accompany the long bench, connecting the promenade with the green behind it. As the bench arrives inside the twisting loops, it bounces off the walls and ceiling to form seats and openings.

A PATH IN THE FOREST

TETSUO KONDO ARCHITECTS
Tallinn, Estonia, 2011

Part of the LIFT11 festival of urban installations, this 95-meter elevated trail meanders through the forest of Tallinn. Supported by a steel tube that rests against the tree trunks, the path relies on the surrounding forest to float through the woods. By raising the trail into the trees, the way one experiences and interacts with nature shifts considerably. This subtle architectural intervention establishes a reciprocal relationship between the man-made and the natural. By leaving the form of the forest untouched, this ephemeral path offers a new way to experience and engage with the wilderness.

TIGER & TURTLE— MAGIC MOUNTAIN

HEIKE MUTTER + ULRICH GENTH
Duisburg, Germany, 2011

This large-scale, undulating public sculpture rises above the nearby Rhine on a man-made mountain. Reminiscent of a classic roller coaster, the curved flight of stairs creates a startling and surreal image, inscribing itself like a signature on the landscape. LED-lights are integrated in the handrails and highlight the flight of stairs so the sculpture remains accessible by night. The visitor traverses the sculpture on foot via steps of varying steepness and the one-meter-wide path generates impromptu meetings between the users. Subtly engaging a dialectic between mobility and standstill, this unique pathway elicits feelings of both wonder and community atop an otherwise stagnant plateau.

THE GARDEN OF 10,000 BRIDGES

WEST 8 URBAN DESIGN & LANDSCAPE ARCHITECTURE + DYJG BEIJING
Xi'an, China, 2009–2011

Much like the winding path of life, this garden design meanders and winds through and over its park site and surrounding lake. Engaging ideas of perspective, limitation, sensation, and surprise, the project offers only one entrance and one exit. The narrow granite path curls through the garden of bamboo, passing over and under each bridge and obscuring how far visitors must go to complete the journey. Only upon reaching the five bridges of the project do visitors reestablish their sense of orientation, gaining insight into their place within the immediate context as well as their greater life stories.

111

SLINKY SPRINGS TO FAME

TOBIAS REHBERGER
Oberhausen, Germany, 2011

A colorful ribbon wrapped in a light, this spiraling pedestrian bridge connects two existing parks on either side of the Rhein-Herne canal. The springy synthetic pavement of the walkway and the colorful patterning of the concrete coating amplify the memorable experience of the bridge throughout the day and night. An occupiable slinky from the top and a glowing sinuous pathway from below, this project recharges the public domain with a sense of playfulness, grace, and wonder.

ORNITHOLOGICAL OBSERVATORY

MANUEL FONSECA GALLEGO
La Rioja, Spain, 2009

Resting between two large trees, this irregularly angled wooden ornithology observatory functions as both a lookout and a covered walkway. Referencing the vernacular of a bird's nest in its striated construction, the project perches on top of a hill, crossing the forest's mass and surpassing the river's vertical edge with a powerful 12-meter-long cantilever. A walkway parallel to the river merges with the main observation area, ensuring a fluid transition between interior and exterior, city and nature.

114 ∞ CHAPTER 03 ~ WALK WITH ME

MOSES BRIDGE

RO&AD ARCHITECTEN
Halsteren, Netherlands, 2011

This biblically inspired sunken bridge establishes access across a seventeenth-century moat to the large Fort de Roovere. Lying like a trench between the fortress and moat, the nearly invisible project blends in with the outlines of the landscape while creating a provocative thoroughfare for passersby. Because the waterline and ground extend all the way up to its edge, the bridge cannot be seen from a distance, maintaining the illusion of an impenetrable fortress. When viewed up close, the waters appear to part, creating a sublime pathway that can vanish at any moment with a change of the tide.

BUNKER 599

ATELIER DE LYON | RIETVELD LANDSCAPE
Diefdijk–Highway A2, Netherlands, 2010

Exposing the secrets within a nineteenth-century military bunker, a long wooden boardwalk leading out to the center of the waterway slices through this seemingly indestructible monument. The dramatic design opens up the modest interior of one of the New Dutch Waterline's 700 bunkers, the insides of which are normally cut off completely from public view. The sliced-up bunker maintains its monumental character while reframing its relationship to nature and making a unique part of Dutch military history accessible and tangible for the general public.

INFINITE LANDSCAPE

RYO YAMADA STUDIO
Sapporo, Japan, 2010

An L-shaped wooden room floating in the water and connected by a single, narrow walkway beckons visitors away from the land and towards a contemplative space for reflection. Visitors approach the room via a 45-centimeter-wide and 14-meter-long walkway, some taking their time and walking in a straight line, others occasionally looking back to confirm how far they have come. The room that awaits encourages people to rethink their surroundings, as it constantly reinvents itself according to the weather and time of day.

118 ∞ CHAPTER 03 ~ WALK WITH ME

LUSATIAN LAKELAND LANDMARK

ARCHITEKTUR & LANDSCHAFT
Senftenberg, Germany, 2008

Rising out of a landscape of brownfield sites characterized by decades of coal mining, this Corten steel landmark towers over its surrounding context. The two-sided project opens up to expose an intriguing composition of sculptural staircases for visitors to traverse when facing the land only to then close off into an impenetrable mass when viewed from the lake. Cloaked in an expressive, reddish patina, this striking observation tower pays homage to the industrial history of the site while simultaneously establishing itself as a contemporary public icon for the region.

MURTURM NATURE OBSERVATION TOWER

TERRAIN: LOENHART & MAYR ARCHITECTS AND LANDSCAPE ARCHITECTS

Gosdorf, Austria, 2010

This sculptural observation tower on the River Mur offers access to the ecology of the surrounding forest and lets visitors experience the river catchment, which changes according to the intensity of the water's flow. Based on the idea of a double helix, the tower is perceived as a continuous path rising up through the trees. The circular double-spiral staircase ascends to the top like a corkscrew, passing through different levels of the forest and enabling visitors to experience the shifting ecosystems and microclimates. After 168 steps, the modest observation platform reveals itself, offering panoramic views of the surrounding countryside.

122 ∞ CHAPTER 03 ~ WALK WITH ME

SELJORD LOOKOUT TOWER

RINTALA EGGERTSSON ARCHITECTS
Seljord, Norway, 2011

The myth about a sea serpent in the lake of Seljord has become an integral part of how the local people of Telemark conceive their majestic landscape. Using this mythical feature as a point of departure for design development, this main viewpoint helps bring the natural phenomena present in the landscape to a broader public audience. The viewing platform manifests as an iconic wooden tower with a main space at the top that overlooks the lake. Two smaller spaces on the way up face a nearby nesting area for birds and the crown of two large pine trees. Offering visitors a broader perception of the surroundings, the lookout becomes a beacon and resting point, connecting the landscapes of the known and the unknown.

124 ∞ CHAPTER 03 ~ WALK WITH ME

FOREST STAIR

SAUNDERS ARCHITECTURE
Stokke, Norway, 2012

Set amongst a great oak forest, this striking sculptural installation for the Sti For Øye sculpture park consists of a series of steel and wooden walkways placed at the highest point of the site. The design plays with the idea of an artificially facilitated foray up above the forest floor, an exclusive elevated outlook. A rusted Corten steel exterior contrasts with the softness of the surrounding landscape, while the wood-clad interior nurtures a warm connection to the forest setting. Such a striking stairway to nowhere achieves its impact through the simple act of raising the viewpoint a few feet into the air. The solitary staircase lends the project a surrealist appearance, evoking the memory of a long-lost ruin shrouded in the wilderness.

TROLLSTIGEN NATIONAL TOURIST ROUTE PROJECT

REIULF RAMSTAD ARCHITECTS
Romsdalen—Geiranger Fjord, Norway, 2012

The Trollstigen plateau offers a comprehensive architectural project in program, complexity, and extension. Perched atop a dramatic plateau, this angular lookout and visitor's complex covers an extensive Norwegian mountain site that takes twenty minutes to traverse on foot. The project's unique vista and approach reflect and enhance its surroundings, offering visitors a richer connection to nature. A narrow, zigzagging walkway clad in Corten steel teeters on the edge of the rock. This winding path culminates in a three-axis lookout over the valley, with the main viewing area cantilevering several meters into the air. Adding to the sublime quality of peering over the edge of a steep cliff, the guard rail panels are replaced with the thinnest of glass. This transparent partition becomes an ephemeral barrier between visitors and the great beyond.

127

CHAPTER 04

BENCHMARKS

ACCOMMODATING THE CITYSCAPE

Art in public space is a practice with a long and established history, and responds to, reflects, and explores the temporal and circumstantial context which it inhabits. In the design field, however, street furniture—here encompassing all kinds of objects and pieces of equipment installed on streets and roads, such as benches, fountains, and street lamps—has always been treated ineffectually, and is now becoming a focal point for a new generation of spatial designers with an invigorated interest in accommodating the urban landscape and saving the modern city from an all too homogenized appearance.

Numerous examples of these new forms of urban accommodation can be found in this chapter. The projects range from pop-up furniture in public spaces to more conventional seating infrastructure. An example of the pop-up concept is the seating arrangement developed by Carmela Bogman and Rogier Martens for the city of Utrecht. Here, aluminum bench tops are attached to three retractable bollards that are manually and hydraulically pumped out of the street pavement for multiple uses by neighborhood residents. More closely adhering to a do-it-yourself philosophy is Martens's Tree Bench, which he was commissioned to create as a temporary seating unit for a public park in Amersfoort. His solution is as simple as it is practical: the basic L-shaped bench is tied to a tree with heavy-duty ratchet straps.

A more classic approach is taken by architects Christian Kronaus and Erhard An-He Kinzelbach in their redesign of a representative public square. The square, in front of a historic courthouse building, has a new parking garage underneath that projects its façade over the courthouse onto the site. Pieces of wooden rectangular furniture shift in height to form an artificial topography for multiple uses.

Paying homage to more soft-edged and wave-inspired forms are projects like the temporary skatebowl by Dave the Chimp in Berlin's Kreuzberg neighborhood, which he built with the help of some local skateboarders, and the multi-use environmental installation Crater Lake by 24° Studio, exhibited at Kobe Biennale 2011, where every area was used as seating for visitors wishing to contemplate their surroundings, thus invoking social interactions within and around the site.

Equally multifunctional is the mobile furniture developed by Austrian architects PPAG for the courtyards of the museum quarter in Vienna, which hosts several cultural organizations, museums and cafés. Here, 116 chromatic oversized modular elements are joined in seemingly endless variations. They can be read as characteristic, recognizable symbols of modern architecture amid preserved, historical buildings, acknowledging the communal aspect of the site and reaffirming the social role of architecture. In the summer they are arranged in varying formations next to each other, on top of each other, and in circles and spirals. In the winter the elements are simply pilled and thereby transformed into building-like structures.

Mexican artist Héctor Zamora's project Daring Leisure as well as Austrian architects Heri & Salli's Flederhaus introduce hammocks into the urban grid, successfully transforming otherwise uninviting spaces in Nagaya, Japan and Vienna, Austria into compelling outdoor lounge areas. Taking this lounging concept in public space to the extreme, Swiss artist Pipilotti Rist, in collaboration with architect Carlos Martinez, wraps an entire inner-city area in picturesque St. Gallen in a large and strikingly red polymer carpet. The continuously flowing surface contains everything from benches to a car.

Often blurring the boundaries between public and private spaces, all of the examples shown in this chapter feature clever yet practical urban furniture pieces that allow for a flexible personalization and configuration within the built public realm. Each caters to a multitude of urban activities and circulation patterns, animating and recreating urban life in surprising ways.

MODIFIED SOCIAL BENCHES

JEPPE HEIN
New York, USA, 2007

This series of bench designs is the result of an investigation of architecture, communication, and social behavior in urban spaces. The bench designs borrow their basic form from traditional park or garden benches but are altered in various degrees to make the act of sitting on them a conscious, physical, and social endeavor. With each modification, the benches reject their typical image as a place for rest and solitude, opting instead to become social activators, fostering exchange between users and passersby. Due to their diverse and exaggerated alterations, the benches end up somewhere between a dysfunctional object, a piece of furniture, and a spirited and engaging social experiment.

133

POP-UP

ROGIER MARTENS & CARMELA BOGMAN
Utrecht, Netherlands, 2010

This playful street furniture emerges out of the pavement based on the needs and interests of local residents. After use, the furniture once again retracts into the ground, appearing as inconspicuous turquoise rectangles. By using several sheets that can be fixed at any height, the pieces can be combined to form a bench, stage, or lounge area.

TREE BENCH

ROGIER MARTENS
Amersfoort, Netherlands, 2011

Derived from the ephemeral growth patterns of mushrooms, this clever bench appears and disappears based on fluctuations in the weather and temperature. The bench easily attaches to trees using a simple suspension system, allowing for the nomadic seating to constantly relocate and inspire new loci for urban activity.

01

02

01 WALNUT LITTER BIN
02 FREEDRAIN
03 CHESTERFIELD PARK BENCH

JOOST GOUDRIAAN
Rotterdam, Netherlands, 2010

03

This series of urban interventions uses original industrial designs and handcraft to investigate whether impromptu, high-end detailing can inspire public interest in the objects. From leather upholstered benches to 24-carat gold-plated manhole covers and elegant wooden trash receptacles, these unsolicited acts of urban refinement beckon passersby to take a second look at their surroundings and reconsider if the status quo really fulfills their desires and expectations of what the public face of a city should look like.

PUBLIC SQUARE AND COURTHOUSE SANKT PÖLTEN

CHRISTIAN KRONAUS & ERHARD AN-HE KINZELBACH
Sankt Pölten, Austria, 2011

This elegant project replaces a previously unused plaza, creating an attractive new urban space for the public. The square maintains a prominent public façade towards the street, inviting users in while also acting as a protective buffer from the busy road once inside. In order to integrate the building's context into the square's design, the façade order of the extant courthouse is projected onto the site. While establishing a dialog between the building and its immediate environment, the project introduces urban furniture elements including benches and planters. These wooden rectangular furniture pieces shift in height to form an artificial topography that caters to a multitude of urban activities and circulation patterns.

138 CHAPTER 04 ~ BENCHMARKS

PLAZA PÚBLICA EN GIBRALEÓN

FRANCISCO BORJA RUIZ-CASTIZO MIRABENT
Gibraleón, Spain, 2010

A radial, three-dimensional pattern emerges out of this public plaza. Comprised of a series of arches, the pattern extrudes from the cobblestones to become urban furniture for seating and lounging, and dips down again to establish circulation paths between bays. Accommodating public forums and informal gatherings, the striated language of the different arches produces a rhythmic visual effect, conveying a sense of movement and fluidity within the plaza.

15/32

FELD72
Vienna, Austria, 2008

This unusual staircase functions as a new urban landmark for the city. Developed from an architectural element that evokes hierarchy and authority, the project transforms this rigid, utilitarian aesthetic into an open public institution. The welcoming staircase creates an active zone for social encounter and relaxation. With one set of stairs sinking into the ground and another ascending into a mountain formation, all functional requirements from disabled ramps to bus stops are integrated into the continuous landscape. By exaggerating the qualities of a traditional stair, its typical singular use becomes subverted, allowing the area to be used in a variety of engaging ways.

LUX—STAHLHOF BELVAL-OUEST

ALLESWIRDGUT
Luxembourg, 2011

Located on the grounds of a former steel mill and situated between a series of industrial high-rise buildings, this outdoor plaza capitalizes on the rich industrial wilderness of the site while simultaneously instilling it with new detailing and increased functionality. Seating areas and new trees concentrate into islands, becoming focal points within larger empty areas. The use of age-friendly materials such as concrete, wood, and untreated steel, in combination with rough detailing, results in a compelling, revitalized public space that pays homage to the industrial patina of its past.

CHARLOTTE AMMUNDSENS SQUARE

1:1 LANDSKAB
Copenhagen, Denmark, 2008

Inspired by Japanese stone gardens, this project is divided into a classic Copenhagen public square with stone paving, a recessed ball court surfaced with black asphalt, and a black rubber playground with a white rocky landscape. The ball court and playground are recessed to the level of the street and flanked by a wide stairway. On the traditional square, one can sit and enjoy food from the café of the Cultural Center, while looking down over the court and rocky landscape. The rocks can be used for climbing, biking, skating, and relaxing. Flowering trees that bloom in bright colors emphasize the landscaped and urban parts of the square while contrasting with the graphic black and white aesthetic of the activity areas.

SKYSTATION

PETER NEWMAN
London, UK, 2009

Inspired by Le Corbusier's iconic lounge chair, this project positions the seated viewer as surveyor of the heavens, presenting a rare opportunity to contemplate the universe and one's place as an individual within it. As a permanent addition to the public realm, the fluid and inviting form can now be found across a number of locations and cities throughout England, generating a type of urban and social constellation that always familiar while also adapting to the nuances of each place.

PAPA AND I

DAVE THE CHIMP
Berlin, Germany, 2011

This playful and modest skatepark reactivates a public plaza in the heart of Berlin's Kreuzberg neighborhood. The concrete form consists of two waves, one big and one small, derived from the image of a father wrapping a child in his arms. Abstracted yet undeniably charming, the protective relationship between the inner and outer surface is further accentuated by the addition of simple smiley faces on each part. Instilling static concrete with personality and heart, this project sends a message of positivity and warmth while encouraging interaction from the local community.

CRATER LAKE

24° STUDIO
Kobe, Japan, 2011

Exhibited at the Kobe Biennale, this multi-use environmental installation serves as a dynamic meeting place for visitors to contemplate and interact with their surroundings. The undulating wooden landscape offers unique and unconstrained settings for enjoying the scenic vista. With every surface capable of accommodating seating, additional stools are set into the middle of the space and can be reorganized according to the user's preferences. The gentle sloping radial surfaces entice people of all ages, generating spatial conditions that allow the smooth structure to fluctuate between playground device, relaxation area, and social hub.

REEF BENCHES

ATELIER REMY & VEENHUIZEN
Zoetermeer, Netherlands, 2009

Rising out of the roof of the Picasso Lyceum secondary school, a series of angular wooden furniture pieces offer space for students to sit, relax, play, eat, and read. Acting as a type of outdoor clubhouse, the project takes the shape of stylized dunes dotted with classic seating elements. The stacked and slatted furniture pieces gradually shift in form, narrowing and expanding to accommodate plateaus for different uses.

CHAPTER 04 ~ BENCHMARKS

VISUAL PERMEABILITY PAVILION

COLUMBIA UNIVERSITY GSAPP
New York, USA, 2011

Part pavilion and part public furniture, this playful project provides multiple spaces for relaxation, contemplation, and social interaction. Composed of two distinct area, one offers space for two people to relax in a more private setting while the other accommodates up to four people at a time for more social gatherings. The angling of the wooden slats maximizes this separation between the public and private zones, establishing a gradient of visual permeability. The form, derived from a single continuous strip, wraps around itself, keeping its connection to the ground at a discrete minimum. The density of the slats varies based on use, with the densest zones designated for walking and sitting, the medium zones for backrest locations, and the lightest zones for shade. The expressive structure entices passersby to come over, sit, and relax.

PARK(ING) DAY INSTALLATION

STUDIOS ARCHITECTURE, HOLMES CULLEY & CHRIS CHALMERS
San Francisco, USA, 2011

This impromptu urban lounge was part of PARK(ing) Day, the annual event that temporarily transforms parking spaces into public spaces. The installation comprised an extruded parking space with a void carved out in the shape of a car, creating an intimate lounge space within. The design utilized reclaimed cardboard printer rolls as the primary building material. No fasteners or adhesives were used in the project, allowing for quick assembly, easy recycling, and minimum waste. Here today and gone tomorrow, the installation demonstrates the potential for reclaiming our urban context for public use.

PLAYGROUND FENCE

ATELIER REMY & VEENHUIZEN
Dordrecht, Netherlands, 2005

This whimsical project rethinks and challenges the role of a traditional fence. By adding an array of protrusions and recesses into a rigid surface, what once functioned solely as a barrier between places can now instigate and welcome human interaction. The incorporation of seats, benches, nooks, and play spaces on both sides of the fence changes a generally static and unfriendly partition into a dynamic meeting point and social hub.

SOUNDS OF SEA

COMPANY
Auckland, New Zealand, 2011

A set of nine interactive polished chrome sculptures stretch along the waterfront of Jellicoe Harbor in Auckland. The typology of the pieces pay homage to the active maritime site, mimicking the air ventilation funnels and speaking tubes used on ships. Reinterpreted into urban furniture that delivers the sounds of the sea from underneath the boardwalk, the largest of these sculptures offer whimsical places to sit, hide, and explore.

152 CHAPTER 04 ~ BENCHMARKS

GRAVITY PASSENGERS

REFUNC
Mafikeng, South Africa, 2010

This social and kinetic experiment consists of three gigantic swings, fabricated from recycled tires and wooden poles. Suspended from Mmabatho Stadium's outer frame, the massive swings face one another and dangle from a staggering height of 12 meters. Each swing carries ten to twenty passengers at a time. Inciting a dynamic interplay with the forces of gravity and ultimately between the different passengers, the communal swings require their users to negotiate with one another about how best to guide their path and velocity.

LAWNGE

LISETTE SPEE & TIM VAN DEN BURG
Breda, Netherlands, 2009

Emerging out of the grass, this undulating lawn furniture serves as a tactile and playful re-interpretation of the traditional lawn chair. Fabricated out of Corten steel and covered in artificial turf, the expressive outdoor lounge furniture seamlessly blends in with surrounding landscaping, nurturing the illusion that each unique chair was created by pulling up a patch of the earth below.

154 CHAPTER 04 ~ BENCHMARKS

PICNURBIA

LOOSE AFFILIATES
Vancouver, Canada, 2011

This 4 × 30 m undulating public structure offers a series of multipurpose spaces for gathering. Covered in bright orange artificial turf, the wave-like form enjoys a sprinkling of beach umbrellas and movable wooden elements that double as benches, tables, and bridges. The softness of the turf and the playful design beg for interaction, encouraging the public to become part of the bustling urban landscape.

YARD FURNITURE MUSEUMSQUARTIER—MULTIFUNCTIONAL MODULARITY

PPAG ARCHITECTS
Vienna, Austria, 2004, ongoing

An ongoing public furniture project for the inner courtyards of Vienna's Museum Quarter consists of 116 oversized seating and lounge elements that can be joined in endless variations. These whimsical, recognizable, and contemporary furniture pieces pay homage to the modern architectural movement in a preserved, historical complex of buildings. In the summer, the pieces are scattered throughout the courtyards in herds, every year in different colors and new formations. During the winter, the elements are placed in piles, transforming into building-like structures where DJ-music can be enjoyed. The playful nature of these geometric objects acknowledges the communal aspect of the site and reaffirms the social role of architecture within the city.

157

158　　　▭　CHAPTER 04 ~ BENCHMARKS

ANEMONE

OYLER WU COLLABORATIVE
Taipei, Taiwan, 2011

This tactile installation weaves together aesthetic experience and sensorial stimulation to form a provocative piece of public furniture. Rejecting the attitude that art can be seen but never touched, this project recognizes the need for human engagement in creating a rich and emotive spatial experience. The interactive multipurpose surface reveals itself gradually, appearing as a smooth, undulating object from afar. Upon closer inspection, one discovers that the surface is actually built from thousands of transparent flexible rods in varying lengths to accommodate different uses. A table/bed-like element at the center of the installation sits below a cantilevered canopy of bristles, encouraging users to engage and immerse themselves in the intense materiality of the form.

DARING LEISURE

HÉCTOR ZAMORA
Nagoya, Japan, 2010

Drawing inspiration from the light shell architecture of Felix Candela and Frei Otto, this installation of hammocks hangs from the geometric entrance of a Japanese museum. The bright red network of hammocks directly contrasts with the postmodern rigidity of the museum building. Elements of play, humor, and leisure work together to transform an otherwise cold and unwelcoming space into a compelling outdoor lounge area.

FLEDERHAUS — COME IN AND HANG OUT

HERI & SALLI
Vienna, Austria, 2011

Located on the square in front of Vienna's Museum Quarter, this playful project offers a moment of tranquility from cosmopolitan life. This prototype for relaxation uses an abstracted shape of a multi-story house to create different spatial openings for hanging individual hammocks. A temporary sequence within a permanent setting, the unconventional public area represents an of urban oasis that achieves a highly emotional impact while only lasting a short time.

EVERGREEN

STUDIO VOLLAERSZWART
Olderzaal, Netherlands, 2009

A functional sculpture covered in artificial grass serves as an engaging public space for secondary school children. The usually flat material of artificial turf achieves three-dimensionality through the oversized letters that splay across a 20-meter circle. Nine huge letters form both the seating area itself and the name of the project, offering a range of whimsical lounging options where adolescents can relax and socialize.

STADTLOUNGE, ST. GALLEN

CARLOS MARTINEZ ARCHITEKTEN & PIPILOTTI RIST
St. Gallen, Switzerland, 2005

This surreal redesign for the Raiffeisen quarter coats the area in a blazing red, surprisingly soft floor covering made of granulated rubber. Boldly attracting visitors, the project acts as a welcoming gesture, breaking up the introverted, heterogeneous character of the district. This haptic and inviting new flooring unifies everything in its path into a homogeneous surface, establishing a convivial atmosphere and playful public lounge space. Surreal furniture and playground elements including a buried car emerge from the carpet, offering tactile and amorphous silhouettes that add deliberate contrast to the hard precision of the built surroundings. By placing this public lounge in the middle of a dense urban context, the façades of the surrounding buildings begin to double as abstract enclosures for the lounge, reframing the boundaries between public and private, indoor and outdoor.

URBAN DOCK LALAPORT TOYOSU

EARTHSCAPE
Tokyo, Japan, 2006

Using the topography of the ocean as a guideline for the overall landscape design, this project comprises a series of gentle waves accented with white benches mimicking sea foam. The undulating ground plane proves very popular with children, inspiring them to spontaneously run and play amidst the waves. Built by reclaiming two old docks, three waves of vegetation, water, and earth are layered over the site, with a café, radio station, and museum scattered throughout to resemble different islands. Considering the entire landscape as an ocean, the people who travel through take on the role of voyagers, sparking a new way to experience and engage with the environment.

KIKUCHI POCKET PARK

TAKAO SHIOTSUKA ATELIER
Kikuchi-City, Japan, 2012

Woven into a dense Japanese neighborhood, this project stands as the first of three parks planned for the area. The narrow site features a unique geometric motif easily identifiable to local residents. The miniature water park collects water in three large indentations in the surface that scatter over the plot. A lavatory, reflective shelter, and bench, all resembling abstracted stone structures, are connected by a consistent white floor paver, evoking the sand of a traditional Japanese rock garden.

165

TEL AVIV PORT PUBLIC SPACE REGENERATION

MAYSLITS KASSIF ARCHITECTS
Tel Aviv, Israel, 2008

Plagued by neglect since the port's abandonment in 1965, this revitalization project restores a unique part of Tel Aviv, returning it to a prominent, vivacious urban landmark. Situated on one of Israel's most breathtaking waterfronts, this new development constructs a public space which challenges the common distinction between private and public, suggesting a new agenda of hospitality for collective open spaces. The design introduces an extensive undulating, non-hierarchical surface that acts as both a reflection of the mythological dunes over which the port was built and as an open invitation to take part in unstructured activities. Various public and social initiatives — from spontaneous rallies to artistic endeavors and public acts of solidarity — cultivate within this unique urban platform. A vibrant public addition and urban icon, this project triggers a series of public spaces along the shore which together revolutionize the city's connection to its waterfront.

167

RIVA SPLIT WATERFRONT

3LHD
Split, Croatia, 2007

In a city famous for its open and accessible waterfront, this redevelopment project respects the site's rich cultural and historical heritage while re-articulating the space for a diverse range of community activities. The act of creating a new integrated surface to harmonize an array of public programs allows the development to adapt to all usage scenarios while retaining the Mediterranean character of the city. The project frees the existing surface of everything superfluous, establishing an infrastructure that meets the needs of contemporary life. The color of the concrete varies from white to pale gray and its arrangement and concept generates a pixel image of a rippling sea when viewed from afar. The modular floor covering provides a framework for all current and future purposes, determining the arrangement of benches, green areas, outdoor cafés, and sunscreens.

CAÑADAS PARK

ABIS ARQUITECTURA
Pliego, Spain, 2010

Forty-two kilometers away from the city of Murcia, two valleys surround a small urban plot, producing a scenic view over the village and nearby valley. The geometric duality of the site allows for a dual program, with cultural events and sporting activities utilizing the natural terraces of the grounds. Spectator stands incorporated into the terraces seat up to 1,000 people in an open-air amphitheater. A botanical garden filled with indigenous Mediterranean plants resides between the two activity zones. These native plant species recreate visual and olfactory sensations of the nearby mountains as they permeate and envelope the park. Once an empty and lifeless area, the park now encourages community interaction through leisure and recreational activities.

ON THE WAY TO THE SEA

DERMAN VERBAKEL ARCHITECTURE
Bat-Yam, Israel, 2010

This minimalist project transforms the interstitial space that lies between the city and the sea into a destination in its own right. A series of white frames carefully positioned between city edge and sea shore hosts a range of activities that vary in levels of privacy. The installation invites the public to intervene, creating opportunities for events and unexpected interactions within the frames. In the gap between city and sea, the project encourages collective and individual participation in both urban and to beach activities. A series of fixed frames that contain movable elements provides a basic infrastructure in which users have the freedom to alter the urban space to accommodate their own private uses. Fulfilling the desire for a private space in the public domain, starting at the city edge, a series of unfolded living room elements offers more intimate apartment layouts that gradually dissolve into communal urban rooms by the time visitors reach the beach.

171

CHAPTER 04 ~ BENCHMARKS

BOTANICAL GARDEN, CULIACÁN

TATIANA BILBAO
Culiacán, Mexico, 2011

Part of a new master plan for the city's botanical gardens, this open-air auditorium serves as just one element of a series in interventions and public space collaborations with 35 high-profile contemporary artists. Offering a contemporary cultural environment to learn and improve one's quality of life, this small outdoor concrete structure in the botanical garden welcomes up to 70 people at a time to watch a short introductory video tour of the grounds. Enclosed by just three walls, the auditorium enjoys the shade of the surrounding trees, providing fresh air and a pleasant climate to its users.

CHAPTER 05

BETWEEN A ROCK AND A HARD PLACE

ARCHITECTURES OF INTERMEDIATE STATUS

With the modern phenomenon of urbanization, which describes the physical growth of urban areas as a result of global change or the increasing proportion of the world's population living in towns, we are faced with a number of essential challenges inextricably linked to the very concept. In an attempt to streamline and mechanize social and infrastructural needs, cities throughout the world, regardless of their age, location, and economic vitality, have contributed to the creation of anonymous and cheerless spaces such as motorways, traffic junctions, underpasses, and other transitory or disused sites. Stuck between a rock and a hard place, these spaces seem doomed to remain undefined and abandoned. Void of identity, the so-called "non-places," as French anthropologist Marc Augé coined them in an essay and book of the same name, do not hold enough significance to be regarded as "places," but rather are referred to as places of transience. This chapter highlights projects from around the world that try to redefine such desolate and inhospitable non-places, providing new and highly vibrant interventions for these areas within the urban landscape.

A pioneering project of this sort is the Eichbaum Opera by Matthias Rick, who recently passed away, and Benjamin Foerster-Baldenius of the Berlin architecture collective Raumlabor. They realized the seemingly impossible goal of temporarily converting a derelict metro station into an opera house, with help from various specialists and members of the local community. While activity and action, rather than structural intervention, were the focal points of the plan, the previously unsavory area became a thriving point of dialog and exchange through educational and cultural programming. Changing public perception and uniting people around the project were integral in making a nicer, safer public space.

Examining the existing architectural plans and reunifying the landscape through their design, a group of Austrian architects led by Peter Fattinger, Veronika Orso, and Michael Rieper transformed a similar no man's land in the city of Linz. First, a strikingly yellow house was built as a temporary cultural and theatrical venue over an urban motorway in the city's outskirts, serving as a place where endorsement or criticism of urban planning could be voiced. In a truly Ballardian twist, the following year a large traffic island, situated only a few hundred meters down this busy Austrian freeway from the yellow house, turned into a circular arena for interaction among both local and international artists.

Along the same lines, a temporary canal-side cinema was constructed under a London motorway flyover by the non-profit organization Assemble, with a team of volunteers completing the project over the course of one month. Seemingly trapped under the motorway, Folly for a Flyover was made from all kinds of recycled and locally reclaimed and donated materials, and remained on this inhospitable site for six weeks. Movies were screened, performances were held, and an enclosed café, bar, and cinema seating space were created, thereby reactivating the surrounding area in unexpected ways.

Treating the city as a living organism requires solutions as dynamic as life itself. These prime examples of acupunctural interventions on an urban level offer adaptable frameworks that promote targeted, small-scale interventions for large-scale maladies, giving vacuous and irrelevant non-places new life in today's urbanized world.

EWHA WOMANS UNIVERSITY

DOMINIQUE PERRAULT ARCHITECTURE
Seoul, South Korea, 2008

EWHA's university grounds double as an extensive urban response to uniting the school and surrounding city through an impressive campus valley. A vibrant hillside with a circulation promenade sliced through it, all interior spaces are carved from these earthen mounds, establishing a heightened relationship to the outdoors. The internal classrooms and forums open onto the central promenade, encouraging community interaction and extending the learning environment into the surrounding landscape. Special public events, concerts, and performances take place within this hybrid space during weekends and evenings. This bold parting of the land beckons both students and passersby alike to gather and engage with one another.

DEN NORSKE OPERA & BALLETT

SNØHETTA
Oslo, Norway, 2008

Overlooking Oslo Fjord, this iconic opera house double as a new cultural landmark and symbol of urban redevelopment in Norway. In order to make the project as accessible as possible, a carpet of horizontal and sloping surfaces extends over the top of the building and out into the surrounding waterfront. These dramatic sloping planes are all open to the public, resulting in a dynamic reinterpretation of the traditional plaza or town square. Becoming a destination in its own right, thanks to this project, going to the opera takes on a whole new meaning with added social value.

MÅLØV AXIS— FLUENT LANDSCAPES

ADEPT
Måløv, Denmark, 2010

A visionary urban landscaping project stages a spatial story that relates to the distinctive character of the surrounding city while establishing a unique experience for citizens and visitors. The designed landscape, inspired by the geometric impact of glaciers when they erode over land, appears as a fluent and playful concrete topography that builds on the historical values of the area. A vibrant outdoor space full of city life, the zigzagging black, purple, and grey planes form a dynamic tiered surface capable of attracting a range of age groups, while intertwining existing cultural values with new models of community building.

181

GREEN SQUARE

URBAN INTERVENTIONS & VALLO SADOVSKY ARCHITECTS

Bratislava, Slovakia, 2011

This whimsical and instant urban intervention enlivens a previously derelict bus terminal under a bridge. An economical yet high-impact solution, the project stands as a provocation to city officials to find a more long-lasting approach to the problematic site. By covering the 1,000-square-meter area in bright green road paint with customized graphics designed by Ondrej Gavalda, the once overlooked site is now glaringly visible. Demonstrating the considerable impact that a simple, community-led design intervention can achieve, local residents can now enjoy a dramatically improved urban atmosphere.

184 ∨ CHAPTER 05 ~ BETWEEN A ROCK AND A HARD PLACE

GARSCUBE LANDSCAPE LINK— THE PHOENIX FLOWERS

RANKINFRASER LANDSCAPE ARCHITECTURE & 7N ARCHITECTS
Glasgow, Scotland, 2010

This project transforms a previously abandoned underpass into a vibrant space for outdoor activities. Giant, abstract aluminum flowers grow out of horizontal bars of seating. Covered in crimson, the bright ground plane wraps up one side of the embankment, increasing the sense of space and openness within the narrow site. The upgraded underpass runs under four separate roads including two 4-lane motorways. Existing found elements from the site are incorporated into the new design, including recycled rocks combined with new stone, Corten steel, and plants, creating an elegant landscaping feature. Lighting integrated into the flowers and seating areas extends the impact of the project well into the evening, attracting a diverse range of users.

REDBALL PROJECT

KURT PERSCHKE
Worldwide, ongoing

This whimsical sculptural installation travels across the globe and inserts itself into each new urban environment with wit and vision. During its multiple-week residency in a city, the ball searches for new opportunities to activate the public sphere. From Barcelona to Abu Dhabi, this playful nomadic intervention rethinks the role of art in public space. By identifying and engaging the sculptural and architectural spaces of a city, this tactile and eye-catching project enlivens the local pubic imagination and connection to a given place.

186 ⌄ CHAPTER 05 ~ BETWEEN A ROCK AND A HARD PLACE

187

CHAPTER 05 ~ BETWEEN A ROCK AND A HARD PLACE

A8ERNA

NL ARCHITECTS
Koog aan de Zaan, Netherlands, 2003

This inspiring project resides just outside of Amsterdam underneath a major highway overpass. The highway, built in the 1970s, produced a brutal cut through the town's urban tissue. This optimistic intervention restores that lost connection between both sides of the town by activating the discarded space under the road. Turning disaster into opportunity, the remarkable space now serves as a vibrant mixed-use area, complete with a mini-marina and panoramic deck for viewing the river. Developed in close collaboration with the local population, the project incorporates everything from a fish and flower shop to a public graffiti gallery. Other activities cultivated at the site include skating, breakdancing, kayaking, soccer, and basketball. From wasteland to focal point, the elevated highway now offers the opportunity to reconnect the village to the forgotten parts of itself.

CHAPTER 05 ~ BETWEEN A ROCK AND A HARD PLACE

FOLLY FOR A FLYOVER

ASSEMBLE
London, UK, 2011

Reinventing a cavernous space underneath a London overpass into a thriving social hub, this project hosts a six-week summer program of cinema and theater. Built with local, reclaimed, and donated materials, the space draws inspiration from the red-brick London vernacular, posing as an imaginary piece of the city's past. By day, the site hosts workshops, events, boat trips, and a cafe. By night, screenings ranging from animation classics to experimental cinema with live scores, light shows, and performances cultivate a thriving open-air theater and community space.

NOMAD

BUREAU A
Paris, France, 2011

This mobile installation was last seen occupying the gardens of the Musée du Quai Branly in Paris, and highlights the role of nomadism within our contemporary culture. The transitory project comprises a collection of caravans, tents, carpets, and stools meant to inspire and promote interaction and spatial awareness. Five informal settlements provide platforms for events, socialization, and community building, enabling the domestication and appropriation of multiple garden spaces. Redesigned caravans provide space for an information area, sound system, and ice cream truck. Canvas fixed to the caravans creates shade while colorful carpets blanket the ground, inviting visitors to linger. Foldable wood furniture inspired by the museum's collection are sprinkled through the site, reintegrating the prized gallery objects back into everyday life.

BMW GUGGENHEIM LAB

ATELIER BOW-WOW
New York, USA, 2011

In its first stop in a nine-city tour, this mobile laboratory stands as the interactive result of a progressive collaboration between the Guggenheim Museum and BMW. Creating a contemporary public forum for lively dialog, the collapsible structure accommodates a variety of public events, including film screenings, lectures, and workshops. Screens and furniture attach to tracks on the main frame, allowing for constant spatial reconfigurations. Curtains span the full length of the space, creating flexible partitions as needed. A tent made of carbon fiber and mesh fabric serves as an engaging urban playhouse for the communities it visits.

BENCH WITH A VIEW

STOCKHOLM FIELD OFFICE
Stockholm, Sweden, 2011

This spatial installation for an outdoor nightclub in Stockholm is located underneath a large highway overpass at the city's southern fringe. The massive overhead bridges offer a striking backdrop for the reflective piece. Siting at the base of one of the concrete supporting arches, the wide mirrored bench encourages visitors to lie down and engage with the installation. Above, the mirror extends six meters along the span of the bridge, pulling the view into the bench and placing the visitor in the midst of an intriguing inverted landscape. The folding mirror offers several perspectives of reflection encompassing the surrounding landscape, nearby people, and even third-person views of oneself.

MIRROR LAB

VAV ARCHITECTS
Olot, Spain, 2011

Growing out of a desire to capture, explore, and experiment with the landscape more than with the extant built form, this almost invisible installation uses minimal architectural intervention to produce a strong visual and spatial impact. The project's value depends on its relationship with the site, and the mirrored intervention serves as merely a tool to investigate the existing views of the landscape. Solely supported by two points, the mirrors inserted into the bridge add a new dimension to the site, doubling and inverting the space from within and reframing nature from without. Pivoting through the center, the door allows visitors to interact with and become part of the installation, immersing themselves in and exploring both the real and reflected landscapes.

204 ⌄ CHAPTER 05 ~ BETWEEN A ROCK AND A HARD PLACE

DÉJÀ-VU

FATTINGER ORSO ARCHITEKTUR.
Linz, Austria, 2011

A temporary venue for an art and culture festival transformed a traffic island into a circular arena for artistic interaction. The impressive roundabout, which connects one of the most frequented highways in Austria, makes up the center of a landscaped park recently erected above the highway. Usually not accessible, the green island became activated with a temporary bridge of scaffolding. An expanding, modular installation, comprising more than 7,000 red crates, represented the basic spatial infrastructure for this engaging public space. Featuring a stage, workshop, storage facilities, and canteen, 500 additional crates acted as building blocks for further alteration of the programmatic layout. During its 17-day life, the roundabout offered a temporary stage for local and international cultural institutions and guest-artists. Attracting more than 8,000 people, the intervention inspired all age groups to collaborate with and redesign their urban environment.

205

BELLEVUE—DAS GELBE HAUS

FATTINGER, ORSO, RIEPER.
Linz, Austria, 2009

This playful yellow structure functioned as a transient experiment in public space-making on the periphery of the city. Straddling a highway on one side and an idyllic pastoral landscape on the other, the temporary structure reflected the proportions of the surrounding residential buildings. The monochrome yellow project offered housing quarters for guest artists, an information kiosk, a cafeteria with terrace, a bicycle rental station, a working and exhibition space, a media room, a library, and a public stage. The multistory wooden frame construction provided over 400 square meters of usable public space. More than 30,000 visitors made use of this artistic and cultural hub during its summer residency. A temporary landmark that facilitated both the spectacular and the commonplace, residents, scholars, and artists came together to develop projects, transforming the site into a collective experience that linked history with the present as well as culture with everyday life.

CHAPTER 05 ~ BETWEEN A ROCK AND A HARD PLACE

EICHBAUMOPER (OAK TREE OPERA)

RAUMLABORBERLIN IN COLLABORATION WITH RINGLOKSCHUPPEN MÜLHEIM, SCHAUSPIEL ESSEN AND MUSIKTHEATER IM REVIER GELSENKIRCHEN

Haltestelle Eichbaum, Germany, 2009

This informal project temporarily transformed a metro station into a public opera house. Once considered a place of aspiration and hope, the station, up until the time of this intervention, became defined by vandalism and fear. The newly built shelter on the square stood out as an architectural symbol of reactivation and transformation, offering workshop space, a conference room, a bar, a cinema, an art gallery, and a reading café. The key participants of the opera consisted of local residents, musicians, and composers who could convey the realities of the context within the imaginative worlds of music and performance. In addition to showcasing the stories of the local community, the noise of the highway and the rhythm of the passing metro played formative parts in driving the opera. Constructed from a neglected station, this project offered a theater setting where all spectators doubled as actors, blurring the separation between theatrical and urban spaces.

CHAPTER 06

WHY DON'T WE DO IT IN THE ROAD?

NEW FORMS OF ENGAGEMENT IN THE CITY

While only a select number of individuals in our society are ever directly involved in the overall design and construction of a city—for example, urban planners, government officials, and developers—the city itself is inhabited, used, and defined by everyone. This seeming disconnect between the designers and the users is, however, often bridged through the intelligent and innovative appropriation and creation of spaces by both individuals as well as collective members of the public. Against the backdrop of the often anonymous and depersonalized big-city life, these interventions actively promote the artistic and architectural commitment to public spaces as a tool for social interaction and cultural communication. They foster public participation and the sense of community through novel forms of creative engagement. By sharing thoughts, ideas, opinions, and information, one can see in these examples the development and implementation of outstanding projects and collaborations. This concluding chapter brings together a variety of examples which demonstrate equally cheerful and political approaches.

Through a series of urban interventions, Spanish architect Gràvalos di Monte's Estonoesunsolar program created usable spaces out of abandoned vacant lots in the city of Zaragoza. The low-cost project shows how small changes can transform a city landscape through imagination and community involvement. The richness of possible ways to use the empty urban plots stems from the indeterminacy of such gaps in the regular urban fabric. Temporary interventions in the city space are dynamic tools that allow for flexible, alternative readings of the city. The project as a whole aims for non-material solutions, establishing an open dialog with the constructed environment through a lighthearted attitude.

Engaged in the creation of a more open, social urban environment, the projects of the French architecture group Collectif Etc. grow from collective action and intelligence, and aim at catalyzing the existing dynamics of the community and their physical environment. Their political reading of the city is featured in the project Place au Changement in Saint-Étienne's Chateaucreux neighborhood. In the design as well as the participation process, it involved its citizens, both in building a proper square and creating its identity as a public space.

Working with a wide range of games and creative processes to develop these new forms of interaction and emergent spaces brings a sense of fun, play, and community involvement to a city. One example of many is the work of street artist and self-proclaimed "urban hacktivist" Florian Rivière, who spontaneously reinvents and diverts public space. His humorous minimal design interventions made with objects found in the street are individual expressions of urban design and do-it-yourself culture, as well as upcyling, which allows citizens to actively reclaim their environment.

With the individual and the collective becoming both the medium and the translator of a deliberately decentralized discourse on creative production within the urban realm, many of these projects can be read explicitly in the tradition of German conceptual artist Joseph Beuys's idea of the "social sculpture," which describes an extended concept of art that strives to structure and shape society and the environment through human activity.

ESTONOESUNSOLAR — THIS-IS-NOT-A-PLOT

GRAVALOSDIMONTE ARQUITECTOS
Zaragoza, Spain, 2009

Part of an initiative to employ workers to clean empty plots in the historic district of Zaragoza, this series of urban interventions creates opportunities for temporary occupation by offering a range of short-term uses and activities. These different public schemes stand as a hybrid of proposals from a group of architects, associations, and neighborhood organizations. The proposals stem from observing different existing urban plots where minimal design intervention has achieved the largest public impact. Allowing for a flexible and alternative reading of the city and its public spaces, these projects aim for the most ethereal solutions, expressing the provisional nature of each intervention and establishing a dialectic with the already constructed surroundings. By creating unprogrammed gaps in the urban fabric, these openings act as windows of opportunity, encouraging creativity and inviting the community to imagine and propose new situations for cultivating vibrant public spaces.

213

PLACE AU CHANGEMENT

COLLECTIF ETC,
Saint Étienne, France, 2011

Intended as a preliminary step in the process of redeveloping a vacant site for housing, this project adds value to the place through the mobilization of the local population. The engagement of as many people and neighborhood associations as possible insured the future maintenance and development of the public space. Built by and for the people, resident involvement consisted of a series of workshops, from carpentry and gardening to illustration and furniture making, to achieve the various design elements of the project. Allowing the occupation of a space in transition, the project functions as a type of urban testing ground where the public can directly impact the layout and design of their built environment.

A NOUS LE PARKING

COLLECTIF ETC,
Strasbourg, France, 2011

A one-day-long installation engaged a series of street furniture modules to transform a parking lot into a bustling public space. Experimenting with different configurations of space, the multipurpose modules, which supported myriad activities including ping pong, soccer, and chess, morphed from tables to benches and back again. The simple wooden modules moved regularly according to individual desires, becoming a breeding ground for meetings, exchanges, and social experiments.

HOLDING PATTERN

INTERBORO
Queens, USA, 2011

This completely demountable and recyclable project existed as part of the 2011 PS1 Young Architects Program. To avoid designing and building something that would need to be thrown away after the summer, the project ensured that all of its components would have a second life. In order to achieve this zero-waste approach, the architects created a spatial hybrid composed of elements that institutions in the neighborhood needed and things that could enhance the experience of the MoMA PS1 courtyard. During the summer, these objects sat under a canopy of ropes, generating a soaring hyperboloid surface. From benches and climbing walls to shade trees, each aspect of the installation upon completion was delivered to more than 50 organizations in Long Island City and beyond. Expanding the client base from one client to over fifty, this inspired installation operated as an extensive urban design project for greater New York.

TABLE FOR 100'S

ATELIER URBAN NOMADS
Fukuoka, Japan, 2011

Drawing influence from the designers' Portuguese heritage and the Japanese context of their project, this installation comprises a massive, meandering table that extends across a Fukuoka rooftop. The project incorporates a series of different spatial typologies to reflect the cultural differences and similarities between having a meal in Japan or in Portugal. The table compresses and expands to accommodate a variety of more intimate and social seating arrangements, encouraging connectivity and a broader awareness of different cultures and customs.

CHAPTER 06 ~ WHY DON'T WE DO IT IN THE ROAD?

TEMPORARY MUSEUM ALMERE

CLAUDIA LINDERS
Homeruskwartier, Almere Poort, Netherlands, 2010

Mirroring the footprint of the actual museum a few kilometers away, this open-air museum made of grass functions as a public living room for the local community. The virtual and temporary spatial appropriation of the museum by the residents gives rise to a shared identity. A range of activities to promote this feeling of community include lectures, dinners, films, weddings, and gardening. Design elements and public facilities such as a large table, an outdoor kitchen, showers, and tents invite and challenge the public to intervene and make use of the 24-hour site. A white wooden framework recreating the contours of the original museum heighten the suggestion of openings and interconnections among the outdoor pavilions, and help blur distinctions between indoor and outdoor.

THE UNION STREET URBAN ORCHARD

HEATHER RING & BANKSIDE OPEN SPACES TRUST
London, UK, 2010

Following the London Festival of Architecture and lasting through the autumn, this disused site was transformed into an urban orchard and community garden. The lush garden established a place for exchange between local residents and visitors, hosting a series of workshops and discussions focusing on biodiversity and urban food growing, alongside film screenings, musical performances, and local community meetings. The orchard was also home to the LivingARK, a zero-carbon pod inhabited during the period of the project to showcase sustainable ways of living. Upon the garden's dismantling, all the trees were distributed to local estates and community gardens as a lasting legacy of the project.

PRINZESSINNENGÄRTEN

NOMADISCH GRÜN
Berlin, Germany, 2009

For half a century, Moritzplatz hid in the shadows of the Berlin Wall. The overlooked corner, once zoned as a motorway junction, now enjoys a new lease on life as a public garden. Developing a vibrant living, working, learning, and meeting place, the project includes an urban public garden and a community run café. A mini-utopia built from transportable organic vegetable plots empowers local residents to grow their own fresh and healthy food. Promoting a sense of community and an exchange of skills and knowledge, the garden cultivates a new style of urban living where people can work together, relax, communicate, and enjoy locally produced vegetables. The urban oasis increases biological, social, and cultural diversity within the neighborhood while pioneering a new way of living together in the city.

MOBILE GASTFREUNDSCHAFT

MACIEJ CHMARA & ANNA ROSINKE
Austria & Liechtenstein, 2011

Using self-initiative to reactivate the public realm, this nomadic wheelbarrow kitchen meandered across western Europe during the summer and fall of 2011. Spontaneously inviting passersby to sit and eat, the project was outfitted with a large wooden table and 10 seats. Generating an impromptu gathering where modest design meets delight and discussion, this temporary space encourages dialog and community building, beckoning strangers to become friends.

URBAN KITCHEN

DANIEL UNTERBERG & ISABELL WEILAND
Berlin, Germany, 2009

Reinterpreting our urban realm, this domestic kitchen appears in public spaces, initiating new communities and activities in the neighborhood. Constructed on a bike trailer, the kitchen is completely independent and movable by bike. Besides having the necessary cooking equipment, the kitchen also includes long tables that invite passersby to take a seat. Pedestrians, neighbors, and friends gather and bring their groceries and recipes to cook with each other. The two tables can be joined in different arrangements, adapting to the particularities of a given place. A large sunshade completes the kitchen, enhancing its visual effect and comfort for its guests.

BLACK BOX REVELATION

MAX DENGLER & RE-MAKE/RE-MODEL
Copenhagen, Denmark, 2011

This graphic, multipurpose project provided a vibrant gathering space for the Trailerpark Festival in Copenhagen. The simple and effective transformation of this extant caravan cut away one of its sides and pushed the rest of the frame into a narrow black box. The imprint of the caravan acted as the only entrance to the interior. Once inside, the walls were covered with blackboard paint to give guests the chance to channel their creativity and design their own unique artwork. Illuminated by both flickering light bulbs and octagonal holes cut out of the ceiling and walls, the intimate room functioned as a man-made interpretation of the night sky. Acting as a flexible and adaptive space throughout the festival, the project accommodated a range of activities and atmospheres, constantly shifting based on the whim and interests of its occupants.

227

RIO CRUZEIRO

HAAS & HAHN
Rio de Janeiro, Brazil, 2008

Blanketing a massive concrete structure built to protect the hill from mudslides during the rainy season, this massive graphic mural was painted in collaboration with local youth. The stunning urban painting sprawls over 2,000 square meters of one of Rio's most notorious slums. The traditional Japanese design of enormous red koi fish swimming down a black and white river was executed by master tattooist Rob Admiraal. Completed in eight months after enduring long periods of rain, shootings, and police occupation, this impressive public artwork now stands as a vibrant marker of hope and unity, empowering and connecting the local community.

CHAPTER 06 ~ WHY DON'T WE DO IT IN THE ROAD?

SANTA MARTA FAVELA PAINTING

HAAS & HAHN
Rio de Janeiro, Brazil, 2010

Situated on the central square of the Santa Marta community in the heart of Rio de Janeiro, this extensive public art project spans over 34 houses. The vibrant urban mural transforms 7,000 square meters of hillside slum into a dynamic new monument for the community. Using a flexible concept of colorful rays that can easily be expanded, the design sweeps across the houses around the square, part of the street, and the local Samba school. A group of local residents were trained and employed to execute the project, revitalizing the cultural identity of the community and adding to its economic growth and potential.

ASSIMILATIONSVERSUCH NR.1

OSA—OFFICE FOR SUBVERSIVE ARCHITECTURE
Cologne, Germany, 2009

These ornately designed traffic junctions attempt to capture the imagined emotional state of an unoccupied urban space. The hand-painted white public doilies exude a formal, individual visual expression while still maintaining their sites' inherent functionality. A driving roundabout, a public table setting, or the last layer of a wedding dress, the intricate designs encourage a range of unexpected and expected uses and interactions, far exceeding their initial concept.

231

LIKE AT HOME

STIFTUNG FREIZEIT
Berlin, Germany, 2011

This 1:1 scale outdoor drawing of an apartment floor plan, complete with windows, doors, and furniture, afforded passersby a unique opportunity to play house on a public piece of sidewalk. Questioning how to use private spaces once they become publicly visible, this 5-hour-long urban intervention reframed one's connection to personal objects and ritual. By situating itself within the public realm, the project infused the private sphere with a refreshing and playful tabula rasa.

DON'T PAY, PLAY !

FLORIAN RIVIERE
Strasbourg, France, 2011–2012

This series of urban interventions applies minimal design intervention to reactivate public space and bring back a sense of fun and play into the city. From making simple outlines on the sidewalk to stringing a net between two abandoned grocery carts, new informal venues for everything from hopscotch and limbo to volleyball quickly emerge. Each example serves as a refreshing reminder of the myriad potentials for reclaiming elements of the built environment for public activity and sport.

BEFORE I DIE

CANDY CHANG & CIVIC CENTER
New Orleans, USA, 2011

This interactive public art project invites people to share their hopes and dreams in an impromptu public setting. Created on the sides of an abandoned house in New Orleans, the project establishes a public message board where people can reflect on their aspirations and remember that which is most important to them. With passersby encouraged to pick up a piece of chalk and fill in the blank following the phrase "Before I die I want to …," this highly personal and highly visible project helps reimagine how our public spaces can better reflect what matters to us, both as a community and as individuals.

FOLKETS PARK ENTRANCE

BYGGSTUDIO
Malmö, Sweden, 2010

This playful large-scale notice board welcomes visitors to Malmö's Folkets Park. The signs display information about the park in addition to personal messages. All signs and lettering are flexible and can be moved and exchanged according to current events and seasons.

237

238 ---- CHAPTER 06 ~ WHY DON'T WE DO IT IN THE ROAD?

DUALITY

ART+COM
Tokyo, Japan, 2007

This installation comprises a covered walkway linking an underground station to an adjacent residential and office complex. The walkway borders a prominent water element that appears as an artificial lake. Inspired by the interplay between the solid pathway and the fluid water, the project expands on this contrast by adding virtual waves of light on the walkway and real waves in the water. White LED panels installed in the walkway measure the exact position and force of each footstep, triggering corresponding virtual ripples. When these ripples of light hit the edge of the lake, mechanical actuators seamlessly translate these patterns into physical waves in the water. By stepping on the LED surfaces, pedestrians generate virtual and real wave patterns, effectively changing the space as they pass through it.

240 ---- CHAPTER 06 ~ WHY DON'T WE DO IT IN THE ROAD?

SUMMER THEATER

KADARIK TÜÜR ARHITEKTID
Rakvere, Estonia, 2011

Built to house 12 plays during the summer, this outdoor theater stage offers a closed, comfortable, and intimate space that facilitates a visceral connection between the audience and the actors. The striated architecture frames the landscape in a way that the park, trees, and nearby pond become integral elements of the stage set. The irregular wooden construction affords a feeling of spaciousness and provides opportunities to develop dramatic lighting and atmosphere. Fabricated out of 50 × 50 mm timber, at the end of the season the entire stage can be dismantled and reused in a different setting, referencing the impermanent nature inherent in the experience of theater.

242 ---- CHAPTER 06 ~ WHY DON'T WE DO IT IN THE ROAD?

OPEN HOUSE

RAUMLABORBERLIN
Anyang, South Korea, 2010

This self-learning laboratory remains in a constant state of flux, initiating a dynamic dialog and collective space for international and local artists as well as the citizens of the community. The project comprises a bar, kitchen, teahouse, children's areas, and workshop spaces. One part vertical village and one part social sculpture, this pubic architectural intervention proves deeply intertwined with and invested in the existing urban landscape and cultural context.

243

244 - - - - CHAPTER 06 ~ WHY DON'T WE DO IT IN THE ROAD?

CHILDREN'S CORNER

SABA—SPONTANEOUS ARCHITECTURE AT THE BEZALEL ACADEMY

Halvad, Surendranagar district, Gujarat, India, 2011

The first built work of third-year students from SABA, this colorful children's corner resides within a greater community farm compound in a rural area of India. The project comprises four open classrooms connected by a large common platform. Each classroom consists of one floor, one wall, and one roof, as well as a library, rest place, and computer stand. A series of interwoven textiles creates informal partitions between the different outdoor rooms, while also providing shade and capturing the vibrant aesthetic of the Indian culture. This modest project, both in terms of economy of budget and design, facilitates a sense of community for the local children and a safe space to gather and explore.

KLONG TOEY COMMUNITY LANTERN

TYIN TEGNESTUE
Bangkok, Thailand, 2011

Situated in the largest and oldest section of informal dwellings in Bangkok, this project works as a tool for the community to tackle some of the social issues plaguing the area. In addition to providing a football court and public playground, the project functions as part of a larger urban development. Designed and built in under three weeks, the project offers a number of social features sorely lacking in the area, including new hoops for basketball, a stage for performances and public meetings, walls for climbing, and communal seating. The main construction's simplicity, repetitive logic, and durability enable the local inhabitants to make adaptations that fit with their changing needs over time.

248 - - - - CHAPTER 06 ~ WHY DON'T WE DO IT IN THE ROAD?

UFO (UNEXPECTED FOUNTAIN OCCUPATION)

EXYZT & EWA RUDNICKA
Warsaw, Poland, 2011

This urban UFO landed atop a disused public fountain in the center of Warsaw. Temporary and self-managed, the whimsical cultural space hosts film screenings, concerts, discussions, flea markets, and special events for elderly people. Flanked by a pool and stepped seating, the project is a vibrant addition to the cultural city fabric. Private rooms within the UFO are available for those who want to enjoy the active public space into the night.

CHAPTER 06 ~ WHY DON'T WE DO IT IN THE ROAD?

YUCCA CRATER

BALL NOGUES STUDIO
Joshua Tree, USA, 2011

Previously used as a fabrication tool to construct an earlier project, this repurposed man-made crater stands as an iconic addition to its stark desert setting. Expanding on concepts borrowed from land art, the rough plywood structure incorporates the vernacular of abandoned suburban swimming pools and ramshackle homestead dwellings scattered across the Mojave. Rock climbing holds mounted on the interior allow visitors to descend into a deep pool of salt water. A leftover remnant of construction transformed into a striking oasis, this imaginative attitude toward recycling generates a surprising refuge and social microcosm in the middle of the great outdoors.

WHY DON'T WE DO IT ON THE STAIRS?

RE-MAKE/RE-MODEL
Copenhagen, Denmark, 2011

Built for the Roskilde Music Festival, one of the most vibrant international urban gatherings, this project employs an open and flexible layout to accommodate different events. Two large stairs, intersected by activity boxes, offer seating with views of the festival grounds, inviting people to find a space that best suits their mood. The multi-purpose stairs face one another, becoming a natural hub for gathering and people watching. By cutting out the underside of the stairs, a giant covered area transforms into a late-night disco after hours.

ABONDANTUS GIGANTUS

LOOS.FM
Enschede, Netherlands, 2011

This temporary pavilion functions as a bustling public space for an annual Dutch festival. The pavilion serves as a meeting point and stage for performances and exhibitions. Evoking the image of a giant Lego church, the pavilion boasts a 20-meter-tall spire. Built from concrete blocks painted in five primary Lego colors, the project evokes feelings of nostalgia and creativity, while the impressive size of the church inspires a sense of awe. The blocks are stacked in a honeycomb brickwork that allows light to pass in between, adding depth and spatiality to the project. Oscillating between massive volume and airiness, the appearance of the form changes constantly, reflecting and absorbing its surroundings.

255

256 ---- CHAPTER 06 ~ WHY DON'T WE DO IT IN THE ROAD?

GEOPARK

HELEN & HARD
Stavanger, Norway, 2008

Located in the heart of Norway's oil industry, Geopark combines the expertise and material resources of the offshore rigs with sustainable urban development. The park generates a playful urban space along the city's waterfront, reclaiming a vacant site adjacent to the Oil Museum. This multipurpose topographic landscape accommodates a diverse selection of activities including biking, skating, climbing, concerts, sports, and relaxation. Constructed with recycled elements from petroleum installations, abandoned oil platforms, offshore bases, and scrap heaps, the park transforms the formerly abandoned site into a bustling social meeting point used by kids and adults alike.

258 ---- CHAPTER 06 ~ WHY DON'T WE DO IT IN THE ROAD?

BIJLMERPARK

CARVE & MARIE-LAURE HOEDEMAKERS
Amsterdam, Netherlands, 2011

The renewal of the main park in southeast Amsterdam reconfigures the spatial and social structure of the previously derelict area. A colorful sports and game esplanade added to the center of the park accommodates a ball court, playing strip, crawling wall, skatepark, and water and sand playground. A series of yellow frames on bright and sparkling pink safety surfaces creates the playing strip, containing different types of rope bridges and a zip-line connecting to the crawling wall. This whimsical structure serves as a multilevel playing wall, and also incorporates public toilets and facilities for the playground manager. On top of one hill, a vibrant skatepark consisting of two connected pools awaits. On top of the other hill, one can find a water and sand playground, an imaginative landscape tailored to the park's youngest visitors.

VAN BEUNINGENPLEIN AMSTERDAM

CARVE
Amsterdam, Netherlands, 2011

A former play and sport area isolated from its surrounding context, this project rejuvenates the site, introducing a positive liveliness into the district. The new park design invites children to play and citizens to find their personal place to pause, relax, and engage. Along the edges of the square, façade gardens, benches, and hedges appear in strategic locations, forming intimate green rooms for locals to sit and socialize. This simple intervention allows the previous hard boundary between private and public space to become less rigid and transition into a colorful, lively zone. The central surface is designated for sports and play with two other multipurpose fields running adjacent to it. A wavy surface with custom-designed towers offers a variety of playful challenges to all ages.

POTGIETER AMSTERDAM

CARVE
Amsterdam, Netherlands, 2010

In an area lacking in public squares and green space, this modest street intervention utilizes public participation to realize its playful pedestrian design. The project reclaims a busy street and rededicates the space for public activity. By changing the site's functional program from traffic and parking into a meeting place and playground, a successful urban beacon for the district emerges. This reclamation of the urban realm by its community manifests as an undulating landscape with interactive play objects integrated into abstract black rubber. The rubber surface invites users to jump, run, interact, relax, and even draw upon it. Becoming an anchor for neighborhood interaction and a new hub for planting trees, the lively program produces a successful public stage for the local community.

THE REAL ESTATE

AL/ARCH & DANA HIRSCH LAISER
Bat-Yam, Israel, 2008

Located in one of the densest cities in Israel, this graphic project offers a new typology for public space that examines the boundaries between public and private domains in the urban landscape. The site appears at the end of a wide residential street that unexpectedly terminates with a massive acoustic barrier wall. Taking advantage of the existing conditions of the wall and vacant land strip, the project creates an unusual public park that allows intimate and private activities to exist within the public domain. The project's main façade toward the residential street consists of a see-through wall with a wooden entry gate leading visitors into a whimsical outdoor room. A continuous textured concrete surface blankets the extant site, gradually wrapping up and over the existing barrier wall. Seven organic wooden niches in various sizes are carved out of this surface to provide protective spaces for gathering, playing, reflecting, and hiding.

BIG YELLOW RABBIT

FLORENTIJN HOFMAN
Örebro, Sweden, 2011

A massive 13-meter-high yellow rabbit transformed a quiet Swedish plaza into an eye-catching destination for the OpenArt biennale. The humorous sculpture played with ideas of exaggerated scale and color to establish a surreal and monolithic beacon that stood in stark contrast to its surroundings. As if dropped from the sky by a giant child, the enlarged cuddle toy became an enticing point for meeting and marveling in the quiet Scandinavian city.

ADDRESS INDEX

1

1:1 LANDSKAB
Denmark
www.1til1landskab.dk
p. 144
Architect: Morgen Arkitektkontor
Engineer: Eduard Troelsgård A/S
Artist: Beatrice Hansson
Entrepreneur: NCC

24° STUDIO
Japan
24d-studio.com
p. 147
Client: Kobe Biennale Organization Committee/City of Kobe/Hyogo Prefecture

3LHD
Croatia
www.3lhd.com
p. 168
Client: City of Split
Photos: Mario Jelavic, Domagoj Blazevic, Damir Fabijanic

7N ARCHITECTS
United Kingdom
www.7narchitects.com
p. 185

A

ABIS ARQUITECTURA
Spain
www.abisarquitectura.com
p. 169
Architects: Rafael Landete Pascual, Angel Benigno González Avilés, María Isabel Pérez Millán, & Emilio Cortés Saura
Client: Pliego City Council, The Ministries of Public Works and Planning, the Ministry of Presidency and Public Administration of the Region of Murcia; Photos: David Frutos

ACXT
Spain
www.acxt.net
pp. 73-75
Photos: Aitor Ortíz

ADEPT
Denmark
www.adeptarchitects.com
pp. 180-183
Client: The municipality of Ballerup; Photos: ADEPT, Kaare Viemose, Enok Holsegaard

AFFLECK + DE LA RIVA
Canada
www.affleckdelariva.com
p. 82
Client: City of Montreal
Photos: Marc Cramer

AL/ARCH
Israel
al-arch.com
pp. 262-263
Client: The city of Bat-Yam

ALICE (ATELIER DE LA CONCEPTION DE L'ESPACE) AT ECOLE POLYTECHNIQUE FÉDÉRAL DE LAUSANNE
Switzerland
alice.epfl.ch
pp. 50-51
Designed by EPFL Students: Ahmed Belkhodja, Augustin Clement, Nicolas Feihl, Olivier di Giambattista, Eveline Job, Martin Lepoutre, Samuel Maire, Benjamin Melly, Adrian Llewelyn Meredith, François Nantermod and the Assistants: Katia Ritz architect from Lausanne, Daniel Pokora architect from Zurich, Olivier Ottevaere architect from London, Dieter Dietz (Head/Alice); Photos: Joël Tettamanti, www.tettamanti.ch, ALICE Studio EPFL

ALLESWIRDGUT
Germany
www.alleswirdgut.cc
pp. 141-143
Photos: Roger Wagner

ARCHITEKTUR & LANDSCHAFT
Germany
architekturundlandschaft.de
pp. 118-119
Upper right photo: Elisabeth Giers

ART+COM
Germany
www.artcom.de
p. 99
pp. 238-239
ART+COM
Client: Obayashi Corporation
Curating: Nanjo] Associates
Photos: ART+COM

ASSEMBLE
United Kingdom
www.follyforaflyover.co.uk
pp. 192-195
Photos: ASSEMBLE, Morley von Sternberg, David Vintiner

ATELIER BOW-WOW
Japan
www.bow-wow.jp
pp. 200-201

ATELIER DE LYON | RIETVELD LANDSCAPE
Netherlands
www.delyon.nl
p. 116
© VG Bild-Kunst, Bonn 2012

ATELIER KEMPE THILL ARCHITECTS AND PLANNERS
Netherlands
www.atelierkempethill.com
pp. 44-45
Client: Rotary Club Rotterdam North, 'Foundation Grotekerkplein' in cooperation with OBR Rotterdam (City of Rotterdam Development Services)
Photos: Ulrich Schwarz

ATELIER OSLO & AWP
Norway
www.atelieroslo.no
p. 13
Client: Sandnes Municipality
Photos: Atelier Oslo & AWP

ATELIER REMY & VEENHUIZEN
Netherlands
remyveenhuizen.nl
pp. 148
Client: Picasso Lyceum,
Photos: Herbert Wiggerman
pp. 151
Client: primary school Het Noorderlicht, Photos: Herbert Wiggerman

ATELIER URBAN NOMADS
Portugal
atelierurbannomads.org
pp. 218-219
Luísa Alpalhão
Client: konya 2023, Travel Front Project; Photos: Luísa Alpalhão, konya 2023, Eishun Murakami

B

BANKSIDE OPEN SPACES TRUST
United Kingdom
www.bost.org.uk
p. 222

BALL NOGUES STUDIO
USA
www.ball-nogues.com
p. 253
Client: High Desert Test Sites
Photos: Scott Mayoral

BALMORI ASSOCIATES
USA
www.balmori.com
pp. 78-79
Client: Bilbao Jardin,
Photos: Iwan Baan
pp. 83-85
Client: Bilbao Ría 2000; Photos: Bilbao Ría 2000, Gonzalo Urgoiti

BARKOW LEIBINGER ARCHITECTS
Germany
www.barkowleibinger.com
p. 12
Visiting Professor: Frank Barkow and Prof. Regine Leibinger, Barkow Leibinger Architects
Local professor: Professor Kyle Talbott and students of the University of Wisconsin-Milwaukee's School of Architecture and Urban Planning; Client: Menomomee Valley Partners; Construction Company: Boldt Construction (Paula Mitchell, Jim Kleinfeldt, Boldt Consulting Services); Sponsors: The Marcus Coperation Steven Marcus, Robert Greenstreet, SARUP
Photos: Tom Harris, Paul Mattek

CONTENTS B-F

BATLLE I ROIG ARQUITECTES
Spain
batlleiroig.com
p. 67
Client: Santander City Council
Collaborators: Albert Gil, architect, Elena Mostazo, horticultural scientist, APIAXXI, engineering
Contractor: SIEC-URAZCA
Photos: Jorge Poo

BEHIN + HA
USA
bbehin22@yahoo.com
pp. 36-37
Client: FIGMENT, ENYA, SEAoNY,
Photos: Behrang Behin

BRUTO
Slovenia
www.bruto.si
p. 72
Landscape architecture: Matej Ku ina; Collaborator: Tanja Maljevac; Sculpture: Primož Pugelj
Client: Society of Soldiers for Northern Border
Photos: Miran Kambi

BUREAU A
Switzerland
www.a-bureau.com
pp. 196-199
Leopold Banchini, Daniel Zamarbide, Guillaume Yersin
Client: Musée du quai Branly
Photos: Thomas Mailaender

BURGOS & GARRIDO
Spain
www.burgos-garrido.com
p. 66
Client: The Municipality of Madrid
Photos: The Municipality of Madrid

BURO LUBBERS LANDSCAPE ARCHITECTURE & URBAN DESIGN
Netherlands
burolubbers.nl
p. 76
Client: DNC vastgoedontwikkeling, Woningstichting Trudo; In cooperation with AWG architecten, Hoen architecten; Photos: Buro Lubbers

BYGGSTUDIO
Norway
www.byggstudio.com
pp. 236-237

C

CABALLERO+COLÓN DE CARVAJAL
Spain
www.caballerocolon.com
p. 77
Photos: Miguel de Guzmán

CANDY CHANG
USA
candychang.com
pp. 234-235
Artist: Candy Chang; Art and design studio: Civic Center
Photos: Civic Center

CARLOS MARTINEZ ARCHITEKTEN
Switzerland
www.carlosmartinez.ch
p. 163
Photos: Marc Wetli, Hannes Thalmann

CARMELA BOGMAN
Netherlands
www.carmelabogman.nl
p. 134
Client: Municipality of Utrecht,
Photos: Rogier Martens & Carmela Bogman

CARVE
Netherlands
www.carve.nl
pp. 258-261

CHRIS CHALMERS
USA
p. 150

CHRISTIAN KRONAUS
Austria
www.kronaus.com
p. 138
Client: BIG Bundesimmobiliengesellschaft m.b.H.; General Planning: ARGE Vasko+Partner Ingenieure und Kronaus Kinzelbach Architekten; Photos: Thomas Ott

CLAUDE CORMIER + ASSOCIÉS INC.
Canada
www.claudecormier.com
p. 25
Client: SDC du Village

CLAUDIA LINDERS
Netherlands
www.claudialinders.nl
pp. 220-221
Client: Ymere/Museum De Paviljoens, Almere; Photos: Maarten Feenstra, Jordi Huisman

COLLECTIF ETC,
France
www.collectifetc.com
pp. 214-216
Graphic Design: Laetitia Cordier, Bérangère Magaud and Ella&Pitr;
Photos: Collectif Etc,

COLUMBIA UNIVERSITY GSAPP
USA
www.arch.columbia.edu
p. 149
Project team: Luis Alarcon, Aaron Berman, Michael Georgopoulos, Eun Ki Kang, Dayeon Kim, Nicole Kotsis, Jeeun Grace Lee, Aaron Mark, Hylee Oh & Steven Sanchez

COMPANY
Finland
www.com-pa-ny.com
p. 152
Client: City of Auckland, New Zealand, Aamu Song & Johan Olin

D

DANA HIRSCH LAISER
pp. 262-263

DANIEL UNTERBERG
Austria
www.stadtkueche.din-a13.eu
p. 225
Photos: Rolf Eusterschulte, Nicole Erbe

DAVE THE CHIMP
Germany
www.davethechimp.co.uk
p. 146
Client: Oxylane Art Foundation
Photos: Hugo Aldatz Alonso, Bernard Romero-Bastil, Chiara Santini, Mischa Leinkauf

DERMAN VERBAKEL ARCHITECTURE
Israel
www.deve-arc.com
pp. 170-171
Client: Bat Yam Municipality
Photos: Yuval Tebol, Derman Verbakel Architecture

DOMINIQUE PERRAULT ARCHITECTURE
France
www.perraultarchitecte.com
pp. 176-177
Photos: Ewha Womans University, André Morin/DPA/Adagp;
© VG Bild-Kunst, Bonn 2012

DU TOIT ALLSOPP HILLIER
Canada
www.dtah.com
pp. 104-105
Client: Waterfront Toronto
Photos: West 8 Urban Design & Landscape Architecture

E

EARTHSCAPE
Japan
www.earthscape.co.jp
p. 164
Architect: Eiki Danzuka
Client: Mitsui Fudosan Co., Ltd./Ishikawajima-Harima Heavy
Photos: Koji Okumura/Forward Stroke, Shigeki Asanuma, all images courtesy of Earthscape

ERHARD AN-HE KINZELBACH
China
www.knowspace.eu
p. 138

EWA RUDNICKA
pp. 250-252

EXYZT
France
www.exyzt.org
pp. 250-252
Client: Fundacja Vlepvnet/Municipality of Warsaw; Photos: Bogusz Bilewski, Emmanuel Gabily, EXYZT

CONTENTS F-L

F

FATTINGER ORSO ARCHITEKTUR.
Austria
www.fattinger-orso.com
pp. 204-205
Client: City of Linz/Linz Kultur
Photos: Peter Fattinger

FATTINGER, ORSO, RIEPER.
Austria
www.bellevue-linz.at
pp. 206-207
Client: Linz 2009 – Kulturhauptstadt Europas Organisations GmbH
Photos: Peter Fattinger, Heimo Pertlwieser/Stadtplanung Linz, Raimo Rudi Rumpler

FELD72
Austria
www.feld72.at
p. 140
Photo: Hertha Hurnaus

FLORENTIJN HOFMAN
Netherlands
www.florentijnhofman.nl
pp. 264-265
Client: OpenArt Biennale Örebro
Photos: Lasse Person

FLORIAN RIVIÉRE
France
www.florianriviere.fr
p. 233
Photos: Julie Roth, Florian Rivière

FRANCISCO BORJA RUIZ-CASTIZO MIRABENT
Spain
p. 139
Photos: Fernando Alda

G

GAËLLE VILLEDARY
France
www.gaellevilledary.net
pp. 90-92
Photos: David Monjou

GARTNERFUGLEN ARKITEKTER
Norway
gartnerfuglen.com
p. 49
Astrid Rohde Wang & Olav Lunde Arneberg
Photos: Gartnerfuglen Arkitekter

GLOBAL ARQUITECTURA PAISAGISTA
Portugal
www.gap.pt
pp. 96-97
Architects: João Gomes da Silva & Nuno Gusmão
Client: APL, Administração do Porto de Lisboa, Camâra Municipal de Lisboa, EDP; Coordination: GLOBAL; Designers: GLOBAL, João Gomes da Silva, P-06, lda Nuno Gusmão; Collaborators: GLOBAL, Catarina Raposo, Filipa Serra, João Félix, Leonor Cardoso, Monica Ravazzolo, Pedro Gusmão; Photos: Leonor Cardoso, João Silveira Ramos

GRAFT
Germany
www.graftlab.com
p. 99

GRAVALOSDIMONTE ARQUITECTOS
Spain
estonoesunsolar.wordpress.com
pp. 212-213
Client: Sociedad Municipal Zaragoza Vivienda; Photos: Ignacio Grávalos, Patrizia Di Monte

GUN ARCHITECTS
Chile
www.gunarq.com
pp. 26-27
Photos: Guy Wenborne, YAP CONSTRUCTO 2011, courtesy Constructo

H

HAAS & HAHN
USA
www.favelapainting.com
pp. 228-229

HEATHER AND IVAN MORISON
United Kingdom
www.morison.info
p. 42

HEATHER RING FOR THE ARCHITECTURE FOUNDATION
United Kingdom
www.architecturefoundation.org.uk
p. 222
Photos: Mike Massaro

HÉCTOR ZAMORA
Brazil
www.lsd.com.mx
p. 160
Credits: Curator Jochen Volz
Photos: Héctor Zamora

HEIKE MUTTER + ULRICH GENTH
Germany
phaenomedia.org
p. 109
Photos: Heike Mutter und Ulrich Genth, Landmarke Angerpark, City of Duisburg, a project by RUHR.2010; © VG Bild-Kunst, Bonn 2012

HELEN & HARD
Norway
www.hha.no
pp. 256-257

HENK HOFSTRA
Netherlands
www.henkhofstra.nl
p. 98
Client: Drachten
Photos: Henk Hofstra

HERI&SALLI
Austria
heriundsalli.com
p. 161
Client: MQ Wien
Realisation: GRIFFNER/Binderholz in cooperation with MQ Wien
Photos: Mischa Erben

HOLMES CULLEY
USA
www.holmesculley.com
p. 150

I-J

IAAC—INSTITUTE OF ADVANCED ARCHITECTURE OF CATALUÑA
Spain
www.fablabhouse.com
p. 39
Photos: Photos Adrià Goula

ICD/ITKE
Germany
www.itke.uni-stuttgart.de
icd.uni-stuttgart.de
pp. 34-35

INTERBORO
USA
www.interboropartners.com
p. 217

ISABELL WEILAND
Austria
www.stadtkueche.din-a13.eu
p. 225

ISLAND-CITY FOLLY WORKSHOP
Japan
maki_kyoto@hotmail.com
pp. 52-53
Architects: Yuki Hyakuda, Youki Minakata, Yuki Ogawa, Tomohiro Kumazawa & Maki Onishi
Client: Fukuoka-city
Supervisor: Masao Yahagi Architects; Stuructural Design: Masato Araya, Atsuhiro Nakahata; Photos: onishimaki+hyakudayuki

J. MAYER H. ARCHITECTS
Germany
www.jmayerh.de
pp. 18-19
Photos: Fernando Alda

JEPPE HEIN
Germany
www.jeppehein.net
pp. 132-133
Courtesy: Johann König, Berlin and 303 Gallery, New York
Photos: Christian Schmidt, T. Kaare Smith, Christian Mosar, Henrik Edelbo

JOOST GOUDRIAAN
Netherlands
joostgoudriaan.nl
pp. 136-137
Photos: Hoed Ketoer, Joost Goudriaan, Prim Top

CONTENTS L-P

K-L

KADARIK TÜÜR ARHITEKTID
Estonia
www.kta.ee
pp. 240-241
Ott Kadarik, Mihkel Tüür, Uku Küttis; Photos: Ott Kadarik

KARO *
Germany
www.karo-architekten.de
pp. 40-41
Antje Heuer, Stefan Rettich, Bert Hafermalz, Photos: Anja Schlamann/ARTUR IMAGES

KURT PERSCHKE
USA
redballproject.com
pp. 186-189

LEOPOLD BANCHINI (BUREAU A)
Switzerland
www.a-bureau.com
pp. 14-15
Client: Ministry of Culture, Kingdom of Bahrain; Photos: Camille Zakharia, Eman Ali

LISETTE SPEE
Netherlands
lawnge.nl
p. 154
Client: City Breda, NL
Photos: Lawnge

LOOS.FM
Netherlands
www.loos.fm
p. 255
Filip Jonker + Michiel de Wit
Client: arts festival Grenswerk

LOOSE AFFILIATES
Germany
www.looseaffiliates.com
p. 155
Architects: Philipp Dittus, Alana Green, Olena Chytra, Katy Young; Client: City of Vancouver; Photos: Krista Jahnke

LUFTWERK
USA
www.luftwerk.net
pp. 30-32
Client: Chicago Office of Tourism and Culture; Photos: Peter Tsai

M

MACIEJ CHMARA & ANNA ROSINKE
Austria
chmararosinke.com
p. 224
Photos: Maciej Chmara, Anna Rosinke

MANUEL FONSECA GALLEGO
Spain
manuelfonsecaarquitecto.blogspot.com
p. 113
Client: Confederación Hidrográfica del Ebro (Ministerio de Medio Ambiente, y Medio Rural y Marino); Photos: Luis Prieto Saenz de Tejada

MARCO CASAGRANDE
Finland
www.clab.fi
p. 38
Client: JUT Group
Project Managers: Delphine, Peng Hsiao-Ting/JUT Group Nikita Wu/C-LAB; Photos: AdDa Zei

MARIE-LAURE HOEDEMAKERS
Netherlands
m-lh.com
pp. 258-259

MAX DENGLER
Germany
pp. 226-227

MAYSLITS KASSIF ARCHITECTS
Israel
www.mkarchitects.com
pp. 166-167
Client: Marine Trust Ltd.; Photos: Galia Kronfeld, Daniela Orvin, Adi Brande, Nir Shaanani

MAZZANTI ARQUITECTOS
Colombia
www.elequipodemazzanti.com
pp. 10-11
Client: Foundation "Pies Descalzos," ONG "Ayuda en Acción;" Photos: Alejandra Loreto, Jorge Gamboa

MIÀS ARCHITECTS
Spain
www.miasarquitectes.com
pp. 93-95
Client: Public – Banyoles City Council, Collaborators: Silvia Brandi, Adriana Porta, Mario Blanco, Judith Segura, Sophie Lambert, Sven Holzgreve, Thomas Westerholm, Oliver Bals, Marta Cases, Julie Nicaise, Lluís A. Casanovas, Anna Mallén, Bárbara Fachada, Marco Miglioli, Josep Puigdemont, Fausto Raposo, Mafalda Batista, Andreu Canut, Antonello Ragnedda Technical Advisor: Albert Ribera; Engineer: Josep Masachs Photos: Adrià Goula

MILLIMETRE
United Kingdom
www.millimetre.uk.net
p. 47

MUSIKTHEATER IM REVIER
Germany
www.musiktheater-im-revier.de
pp. 208-209

N

NABITO ARCHITECTS
Spain
nabitoarchitects.com
pp. 80-81
Client: Frosinone's Municipality; Photos: Claudia Pescatori

NEX ARCHITECTURE
United Kingdom
www.nex-architecture.com
p. 33
Alan Dempsey & Alvin Huang
Client: Architectural Association, Design Research Lab
Photos: James Brittain

NL ARCHITECTS
Netherlands
www.nlarchitects.nl
pp. 190-191
Photos: NL

NOMADISCH GRÜN
Germany
www.prinzessinnengarten.net
p. 223

NOURA AL SAYEH
pp. 14-15

O-P

OAB OFFICE OF ARCHITECTURE IN BARCELONA
Spain
www.ferrater.com
pp. 100-101
Photos: Alejo Bagué

OBSERVATORIUM
Netherlands
www.observatorium.org
pp. 58-59
Photos: Roman Mensing, observatorium

OSA OFFICE FOR SUBVERSIVE ARCHITECTURE
Germany
www.osa-online.net
pp. 230-231
Anja Ohliger, Stephan Goerner, Ulrich Beckefeld; Client: plan 09 – Forum aktueller Architektur in Köln; Photos: osa

OYLER WU COLLABORATIVE
USA
oylerwu.com
pp. 158-159
Project Design Team: Dwayne Oyler, Jenny Wu, Chris Eskew, Matt Evans, Richard Lucero, Sanjay Sukie, JUT Land Development Group; Photos: Oyler Wu Collaborative

P-06 ATELIER
Portugal
www.p-06-atelier
pp. 96-97

PAREDES PINO
Spain
www.paredespino.com
pp. 20-23
Photos: Paredes Pino & Jorge López Conde

PATKAU ARCHITECTS
Canada
www.patkau.ca
p. 48
Architects: John Patkau, Patricia Patkau, James Eidse
Client: The Forks Renewal Corporation; General Contractor: Peter Hargraves/Sputnik Architecture
Photos: James Dow

CONTENTS R-S

PETER NEWMAN
United Kingdom
www.futurecity.co.uk
p.145
Client: Futurecity;
Photos: Peter Newman

PETER SHARPE, KIELDER ART AND ARCHITECTURE PROGRAMME
United Kingdom
kielderartandarchitecture.com
p.46-47

PIPILOTTI RIST
www.pipilottirist.net
p.163

PORRAS LA CASTA
p.66

PPAG ARCHITECTS
Austria
www.ppag.at
pp.156-157
Photos: PPAG, Roland Krauss

PRICE AND MYERS ENGINEERS
United Kingdom
www.pricemyers.com
pp.46-47

R

RANKINFRASER LANDSCAPE ARCHITECTURE
United Kingdom
www.rankinfraser.com
p.185
Client: Glasgow Canal Regeneration Partnership; Photos: Dave Morris

RAPHAËLLE DE GROOT
www.raphaelledegroot.net
p.82

RAUMLABORBERLIN
Germany
www.raumlabor-berlin.de
pp.242-243
Photos: Anyang Public Art Project (APAP 2010), raumlaborberlin
pp.208-209
Photos: Rainer Schlautmann, raumlaborberlin

RE-MAKE/RE-MODEL
Germany
www.remake-remodel.de
pp.226-227
Photos: Johanne Fick, Kenneth Nguyen
p.254
Client: Roskilde Festival;
Photos: Jimmi Thøgersen, Andreas Houmann

REFUNC
Netherlands
www.refunc.nl
p.153
Client: Cascoland

REIULF RAMSTAD ARCHITECTS
Norway
www.reiulframstadarkitekter.no
pp.126-129
Client: The Norwegian Public Roads Administration, Reiulf Ramstad Architects; Responsable Project manager: Reiulf D Ramstad; Project manager: Christian Skram Fuglset; Structural Engineer: Dr Techn. Kristoffer Apeland AS, Oslo Norway; Photos: Reiulf Ramstad Architects, diePhotodesigner

RINGLOKSCHUPPEN MÜLHEIM
Germany
www.ringlokschuppen.de
pp.208-209

RINTALA EGGERTSSON ARCHITECTS
Norway
www.rintalaeggertsson.com
p.55
Architects: Vibeke Jenssen, Kaori Watanabe, Sami Rintala and Dagur Eggertsson
Client: Public Construction and Property Management
User representative: Norwegian Directorate for Children, Youth and Family Affairs; Curator: Public Art Norway (KORO); Building team: Dagur Eggertsson, Julian Fors, Fabricio Ferreira Fernandes, Matthew Donnachie, Sölvi Magnússon, Kaori Watanabe and Vibeke Jenssen;
Photos: Pasi Aalto
pp.56-57
Photos: Dag Jenssen

pp.122-123
Architects: Vibeke Jenssen, Dagur Eggertsson, Sami Rintala and Kaori Watanabe
Client: Municipality of Seljord
Curator: Springer; kulturstudio; Landscape architect: Feste Grenland; Engineering: Sweco Norge; Contractor building: Skorve; Lights: iGuzzini illuminazione; Funding: Ministry of Regional affairs, County of Telemark, Municipality of Seljord, Telemark Development Fund, Public Art Norway (KORO) and Seljord Society of Commerce; Photos: Dag Jenssen

RIOS CLEMENTI HALE STUDIOS
USA
www.rchstudios.com
p.24
Mark Rios, FAIA, FASLA, principal; Samantha Harris, ASLA, LEED AP; Chris Adamick, LEED AP
Client: The Main Plaza Conservancy; Photos: Nick Simonite

RO&AD ARCHITECTEN
Netherlands
www.ro-ad.org
pp.114-115
Credits: Ro Koster, Ad Kil, Martin van Overveld; Client: Municipality of Bergen op Zoom

ROBERT DESJARDINS
p.82

ROGIER MARTENS
Netherlands
rogiermartens.nl
p.134
Client: Municipality of Utrecht
Photos: Rogier Martens & Carmela Bogman
p.135
Client: Municipality of Amersfoort
Photos: AANDEBOOM

RUBIO & ÁLVAREZ-SALA
Spain
www.rubioalvarezsala.com
p.66

RYO YAMADA STUDIO
Japan
ryo-yamada.com
p.117
Client: Sapporo Art Park;
Photos: Ryo Yamada

S

SABA—SPONTANEOUS ARCHITECTURE AT THE BEZALEL ACADEMY
Israel
spontaneous-architecture.blogspot.com
pp.244-245
Architects: Jonathan Alon, Yael Johnson, Rajendra Menaria, Matan Pisante, Mevaseret Recanati
Client: CEE India, The Center for Rural Knowledge, Halvad
Photos: Tamar Alon, SABA

SAUNDERS ARCHITECTURE
Norway
www.saunders.no
pp.124-125
Architects: Todd Saunders, Attila Béres, Ken Beheim-Schwarzbach
Client: Stokke Municipality and Sti For Øye Sculptural Park; Landscape architects: Rainer Stange, Dronninga Landskap; Photos: Bent René Synnevåg

SCHAUSPIEL ESSEN
Germany
www.schauspiel-essen.de
pp.208-209

SELGASCANO
Spain
www.selgascano.net
pp.16-17
Photos: Iwan Baan, © VG Bild-Kunst, Bonn 2012

SERGIO GARCÍA-GASCO LOMINCHAR
Spain
www.enproyecto.es
p.46
Client: Gobierno de Castilla- La Mancha

SNØHETTA
Norway
www.snohetta.com
pp.60-61
Client: Norwegian Wild Reindeer Center; Photos: Ketil Jacobsen, diephotodesigner.de
pp.178-179
Photos: Jiri Havran

CONTENTS S-W

STIFTUNG FREIZEIT
Germany
www.stiftungfreizeit.com
p. 232
Photos: Stiftung F R E I Z E I T

STIG L. ANDERSSON
Denmark
sla.dk
pp. 64-65
Client: SEB Bank & Pension
Photos: Jens Lindhe and OREV Vandingssystemer

STOCKHOLM FIELD OFFICE
Sweden
www.stockholmfieldoffice.se
p. 202
Credits: Mattias Beckman, Rutger Sjögrim, Markus Wagner; Built with the help of Fredrik Andersson and Emelie Rejsjö; Client: Trädgården, Stockholm

STUDIO ANNE HOLTROP
Netherlands
www.anneholtrop.nl
p. 54
Client: Museum De Paviljoens
Photos: Bas Princen

STUDIO VOLLAERSZWART
Netherlands
www.vollaerszwart.com
p. 162
Architects: Madje Vollaers & Pascal Zwart
Client: Carmel van Thij College
Photos: Pascal Zwart

STUDIO WEAVE
United Kingdom
www.studioweave.com
p. 47
Photos: David Williams
pp. 106-107
Client: Arun District Council
Photos: David Barbour and Studio Weave

STUDIOS ARCHITECTURE
USA
www.studios.com
p. 150
Architects: Anne De Anguera, Matthew Covall, Jason McCarthy, Brian Nee, Justin Glover, Sho Yoshino, Andrew Clemenza, Tanya Retherford, Paul Roberts, Bill Tremayne, Chris Chalmers
Photos: STUDIOS Architecture

T

TAKAO SHIOTSUKA ATELIER
Japan
www.shio-atl.com
p. 165

TATIANA BILBAO
Mexico
www.tatianabilbao.com
pp. 172-173
Photos: Iwan Baan

TEMA URBAN LANDSCAPE DESIGN
Israel
www.temaland.com
pp. 86-87
Client: Gav-Yam
Photos: Amit Geron

TEMPELHOFER FREIHEIT
Germany
www.tempelhoferfreiheit.de
pp. 68-69
Photos: Tempelhof Projekt GmbH, Christo Libuda

TERRAIN: LOENHART & MAYR ARCHITECTS AND LANDSCAPE ARCHITECTS
Germany
www.terrain.de
pp. 120-121
Client: Gemeinde Gosdorf Orts- und Infrastrukturentwicklungs KG
Photos: terrain, Hubertus Hamm, Marc Lins

TETSUO KONDO ARCHITECTS
Japan
www.tetsuokondo.jp
p. 108
Client: LIFT11
Photos: Tetsuo Kondo Architects

TIM VAN DEN BURG
Netherlands
lawnge.nl
p. 154

TOBIAS REHBERGER
Germany
www.tobias-rehberger.de
p. 112
Client: Emschergenossenschaft
Photos: Roman Mensing

TONKIN LIU
United Kingdom
www.tonkinliu.co.uk
pp. 102-103
Architects: Mike Tonkin, Anna Liu, Neil Charlton
Client: Kent County Council, Sea Change, CABE, Dover Harbour Board, Dover District Council; Photos: Mike Tonkin, Robbie Polley

TYIN TEGNESTUE
Norway
www.tyintegnestue.no
pp. 246-249
Client: Klong Toey Community

U-W

UNITED VISUAL ARTISTS
United Kingdom
www.uva.co.uk
p. 28
Client: Commissioned by Cadillac Fairview, Lanterra Developments & Maple Leaf Sports; Photos: James Medcraft © United Visual Artists 2010
p. 29
Client: The Creator's Project Score by Scanner; Additional audio programming: Henrik Ekeus and Dave Meckin; Photos: James Medcraft © United Visual Artists 2011

UNIVERSITY OF WISONSIN MILWAUKEE
USA
www4.uwm.edu
p. 12

VALLO SADOVSKY ARCHITECTS
Slovak Republic
www.vallosadovsky.sk
p. 43
Architects: Matúš Vallo, Oliver Sadovský; Credits: Martin Lepej; Photos: Pato Safko
p. 184
Architects: Matúš Vallo, Oliver Sadovský; Credits: Dušan Chupá; Photos: Pato Safko

VAV ARCHITECTS
Australia
www.vavarchitects.com
p. 203
Photos: VAV, Miquel Merce

WEST 8 URBAN DESIGN & LANDSCAPE ARCHITECTURE BV.
Netherlands
www.west8.nl
p. 66
pp. 70-71
Client: City of Miami Beach
Photos: Robin Hill
pp. 104-105
Client: Waterfront Toronto
Photos: West 8 Urban Design & Landscape Architecture
pp. 110-111
Client: Xi'an International Horticultural Exhibition; Photos: West 8 Urban Design & Landscape Architecture

GOING PUBLIC

PUBLIC ARCHITECTURE, URBANISM AND INTERVENTIONS

Edited by Robert Klanten, Sven Ehmann, Sofia Borges, Matthias Hübner, and Lukas Feireiss

Preface and chapter introductions by Lukas Feireiss
Project texts by Sofia Borges

Cover by Matthias Hübner for Gestalten
Cover photography by Iwan Baan
Layout by Matthias Hübner for Gestalten
Typefaces: Drogowskaz by Emil Wojtacki, Zimmer by Julian Hansen
Foundry: www.gestaltenfonts.com

Project management by Rebekka Wangler for Gestalten
Project management assistance by Andres Felipe Ramirez for Gestalten
Production management by Vinzenz Geppert for Gestalten
Proofreading by Rachel Sampson
Printed by Optimal Media GmbH, Röbel/Müritz
Made in Germany

Published by Gestalten, Berlin 2012
ISBN 978-3-89955-440-3

© Die Gestalten Verlag GmbH & Co. KG, Berlin 2012
All rights reserved. No part of this publication may be reproduced or transmitted in any form or by any means, electronic or mechanical, including photocopy or any storage and retrieval system, without permission in writing from the publisher.

Respect copyrights, encourage creativity!

For more information, please visit www.gestalten.com.

Bibliographic information published by the Deutsche Nationalbibliothek.
The Deutsche Nationalbibliothek lists this publication in the Deutsche Nationalbibliografie; detailed bibliographic data are available online at http://dnb.d-nb.de.

None of the content in this book was published in exchange for payment by commercial parties or designers; Gestalten selected all included work based solely on its artistic merit.

This book was printed according to the internationally accepted ISO 14001 standards for environmental protection, which specify requirements for an environmental management system.

This book was printed on paper certified by the FSC®.

Gestalten is a climate-neutral company. We collaborate with the non-profit carbon offset provider myclimate (www.myclimate.org) to neutralize the company's carbon footprint produced through our worldwide business activities by investing in projects that reduce CO_2 emissions (www.gestalten.com/myclimate).